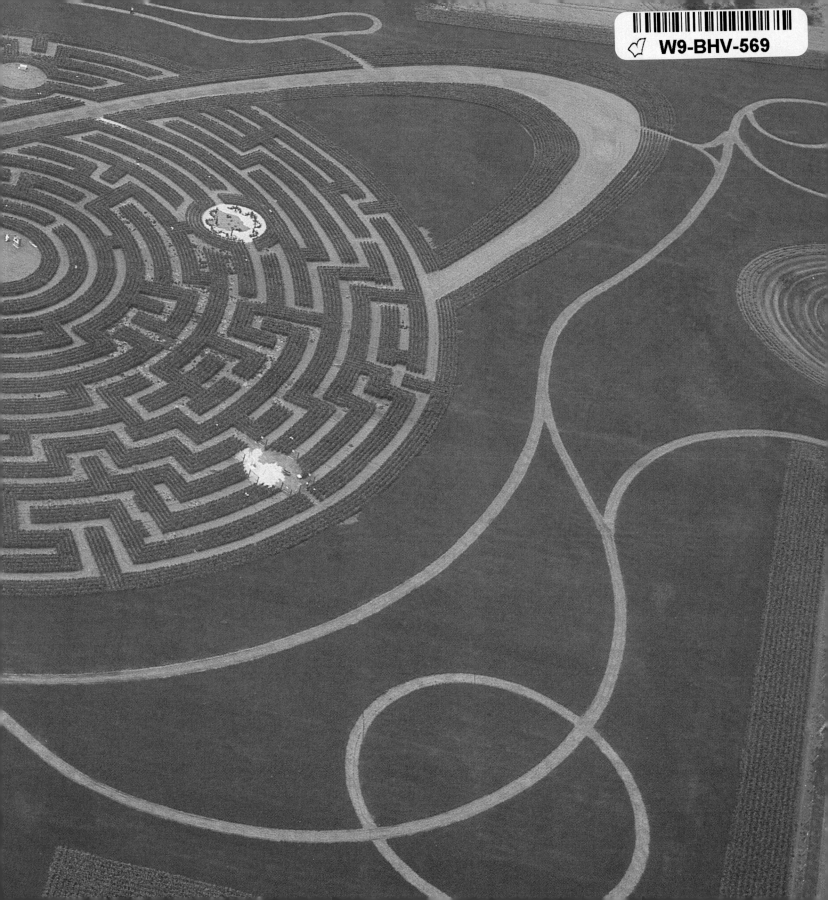

W9-BHV-569

LABYRINTHS

Ancient Paths of Wisdom and Peace

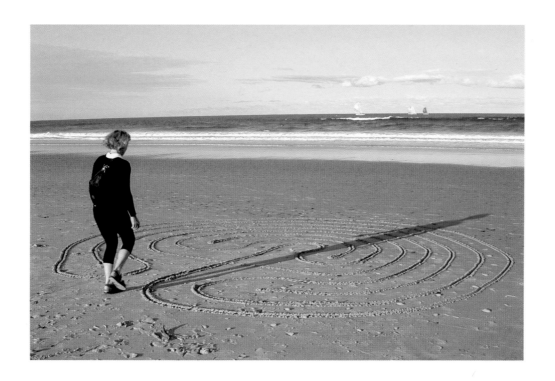

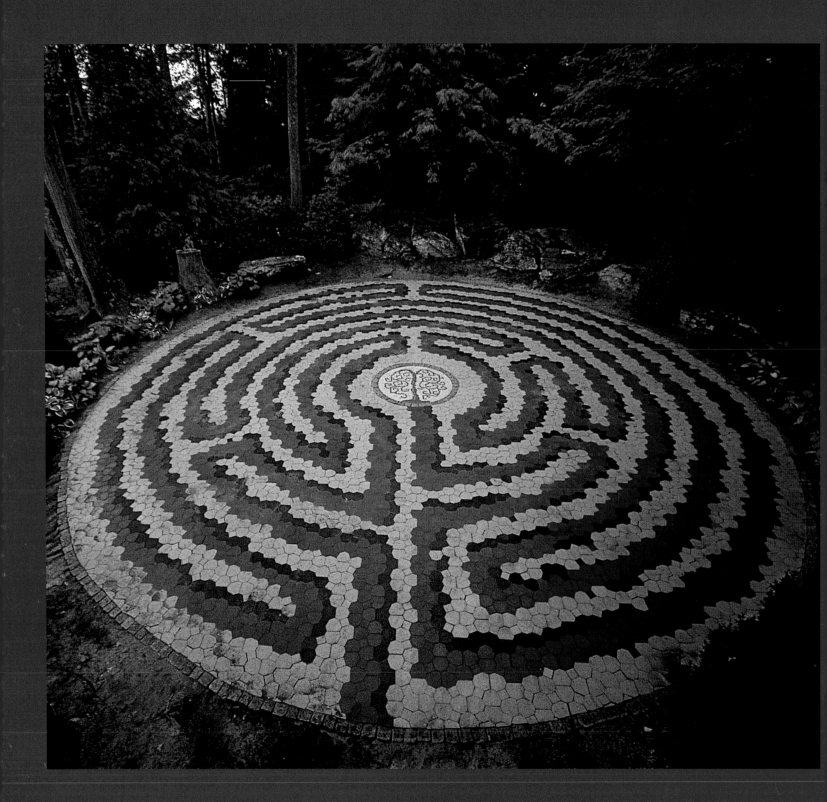

LABYRINTHS

Ancient Paths of Wisdom and Peace

Virginia Westbury

Principal Photographer Cindy A. Pavlinac

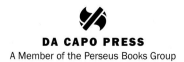

DA CAPO PRESS

A Member of the Perseus Books Group

AD is referred to in the text as CE (Common Era)
BC is referred to in the text as BCE (Before Common Era)

Text © Copyright 2001 by Virginia Westbury
Photography © Copyright 2001 by Cindy A. Pavlinac/Sacred Land
Photography © Copyright 2001 by Jeff Saward/Labyrinthos
and other photographers as listed on page 110
Design © Copyright 2001 by Lansdowne Publishing Pty Ltd

ISBN 0-306-81310-6
Published by Da Capo Press
A Member of the Perseus Books Group
www.dacapopress.com

Originally published in Australia by Landsdowne Publishing Pty Ltd
Commissioned by: Deborah Nixon
Production Manager: Sally Stokes
Text: Virginia Westbury
Principal photographer: Cindy A. Pavlinac
Cover design: George Restrepo
Principal designer: Andi Cole
Internal design and layouts: Andi Cole & Virginia Westbury
Editor: Sarah Shrubb
Project Co-ordinator: Kate Merrifield

All rights reserved. No part of this publication may be reproduced,
stored in a retrieval system, or transmitted in any form, or by any
means, electronic, mechanical, photocopying, recording, or otherwise,
without the prior written permission of the publisher.

Set in Lithos and Bembo on QuarkXPress
Printed and bound in Singapore by Imago Productions

Quotations
p9: Ursa Krattiger Tinga, Zurich, courtesy Labyrinth Project International
p23: Tammuz and Ishar, *Stephen Langdon, Clarendon Press, 1914*
p47: The Idea of the Labyrinth from Classical Antiquity Through the
Middle Ages, *Penelope Reed Doob, Cornell University Press, 1990*
p47: The Consolation of Philosophy, *trans. Richard Green,*
Bobbs-Merrill, 1962
p79: The Essential Rumi, *trans. Coleman Barks*
with John Moyne, Harper, 1995

Illustrations
Page 2: Tree of Life Labyrinth, Connecticut, USA by Adrian Fisher.
Page 4: Decoration from the Watts Chapel, Compton Surrey, U.K.
Page 5: (from top) Labyrinth in Denmark; finger meditation tool
by Sue Anne Foster, U.S.A.; Dancers on the Grace Cathedral
outdoor labyrinth, California.
Page 6: Angel with labyrinth, Watts Chapel, Compton Surrey, U.K.

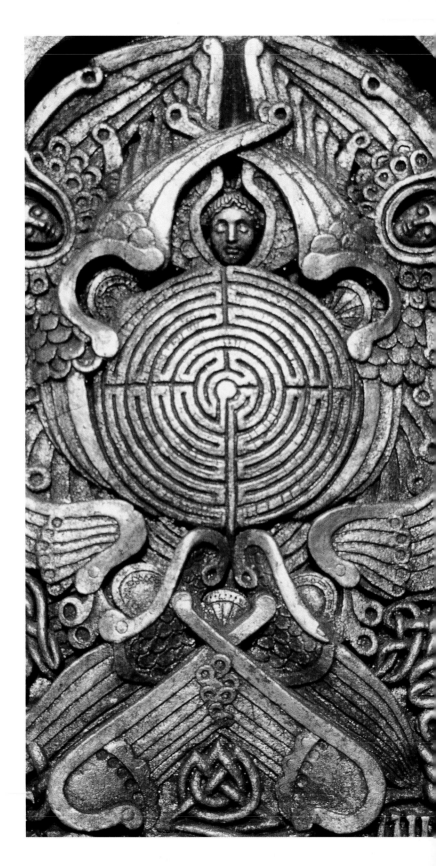

CONTENTS

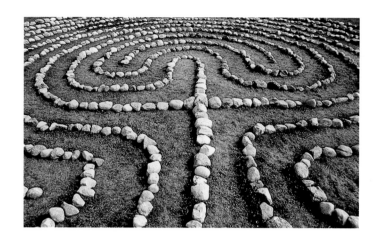

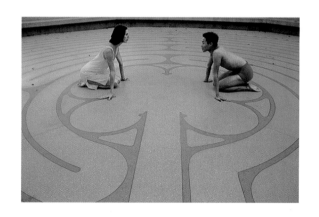

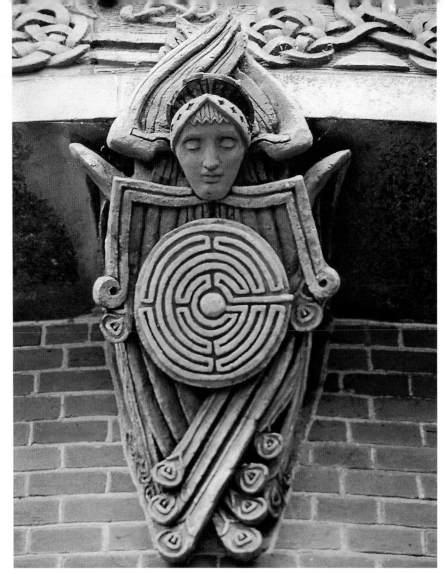

For My Father and Mother

ACKNOWLEDGEMENTS

My thanks to Cindy Pavlinac for her dedication and hard work, Jeff Saward for his much valued information, advice and fact checking, Helen Curry and The Labyrinth Society for all the assistance given, Susanne Kramer-Friedrich of The Labyrinth Project International, Switzerland and Silke Wolf in Germany for their kind help in translation and picture gathering, and all the labyrinth keepers, artists and designers around the world who so generously contributed experiences, pictures and advice for this book. My grateful thanks also to the British Tourist Authority, New York and to the French Government Tourist Office, Los Angeles for their assistance. Finally, a special thanks to my husband, Peter, without whose generous assistance and technical support this book would not have been produced.

FOREWORD

As we round the corner into the 21st century, it seems we are beginning at last to understand the importance of integrating mind, body and spirit in order to achieve true health and wellbeing. We are beginning to recognize the inexorable connection between all things and the ultimate oneness of being. The current interest in labyrinths and the practice of using them for walking meditation is evidence of this spiritual revolution.

More than a million people have walked a labyrinth in the U.S.A. and more than 1000 labyrinths exist across at least 35 states. The success of the global Labyrinth Society since its founding two years ago is due to the profound fascination that these ancient archetypal symbols seem to hold for so many of us. No other tool can so successfully bring into alignment the many aspects of our being and teach us so clearly that we are all on the same path. Nothing else seems to speak so effectively to people of different religious and cultural backgrounds. People today appear to be ready to embrace the labyrinth as a pathway to psychological and spiritual growth. In fact, they are crying out for it. In churches, schools, prisons, hospitals, retreat centers and corporations, it is being used to enhance healing, for stress reduction, problem solving, calming the mind and revitalizing the spirit.

Many people have been profoundly touched by the labyrinth experience. Those walking out of therapy sessions on Thursday evenings, out of workshops on Saturday afternoons and out of churches on Sunday mornings are not saying the kinds of things that we hear as people come out of the labyrinth: *I never dreamed it would be so moving. It was a transformational experience.*

In *Labyrinths: Ancient Paths of Wisdom and Peace,* Virginia Westbury takes us on a journey through the history of labyrinths and masterfully explores and explains the reasons for the current labyrinth revival that is sweeping Western societies. In addition to beautiful color photos of labyrinths from all over the world, she provides us with a comprehensive and easy-to-read book with fresh observations about the labyrinth's importance, past and present.

This book is a journey worth taking for anyone who is interested in learning more about these intriguing and intricate designs and their unique ability to capture our imaginations, our hearts and our spirits.

Helen Curry
President, The Labyrinth Society,
and author of *The Way of the Labyrinth*

THE MYSTERY RETURNS

Since the last decades of the 20th century, an ancient mystery has been reappearing in our midst. The strange and sinuously beautiful labyrinth—born sometime in the Bronze Age and still going strong—has been emerging once again across the landscape of the industrialized world, reasserting itself as one of the pre-eminent symbols and playthings of the human imagination.

Throughout Europe and the Americas, Australia and New Zealand, it has been appearing, in new and creative forms, in public squares, parks and churches, hospitals, retreat centers and wilderness areas, in private gardens, schools and even alongside freeways. In the U.S.A. alone there are now thousands of labyrinths, as well as dozens of puzzle mazes, and the numbers are growing. The last time the world saw such a passion for these devices was during the Middle Ages, an era not unlike our own, in many ways.

At first glance, the labyrinth strikes us as one of the stranger products of human imagining—a winding path leading through a series of seemingly endless twists and turns, into a center and out again. What is its purpose? Today, it is walked mainly for meditation and a sense of inner peace, although it has many other applications, too, as you will see. A labyrinth is different from a maze. They are related, of course—cousins, you might say, although labyrinths came first. Mazes have many paths and dead ends; they are about multiplicity, choice, strategy. Labyrinths have just one path. They are about guidance, trust, reflection. This book is primarily concerned with labyrinths because, while mazes are making a comeback, too, it is the labyrinth's spiritual connotations which are absorbing much of our attention in the West today.

Why are we in love with this ancient device once again? It might be wise for us to seek an answer to that question, for very obviously a movement of this size represents more than a passing fad, and the passion aroused by

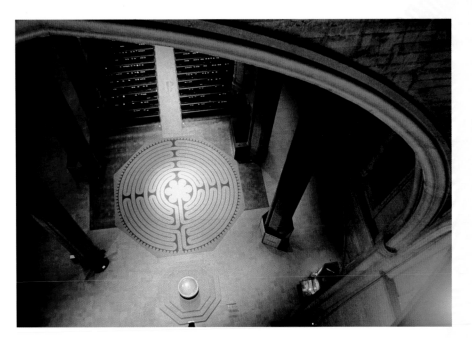

Below: The modern labyrinth, Grace Cathedral, San Francisco, U.S.A.

labyrinths in some communities hints at important underlying needs. Significantly, it is being seen mainly as a tool for peace and guidance in a world which appears to have little to offer in these departments. Its allure may be simply that its one-track path implies that there is a way through the wilderness of our stress-filled lives. It offers us the hope of order in a disordered world, perhaps.

No one can say where it comes from. The labyrinth began as a mystery and remains one, a divine mystery some would say, one that originates in the stars, I have been told, and maybe beyond. Whenever I hear this kind of talk, I am reminded of the first creature to be associated with a labyrinth, the god-like, bull-headed Minotaur of ancient Crete, known also as Asterius, the 'starry one.' Throughout history, the ancient path has been presented alternately as a maze, a prison, a dancing ground, a sacred precinct, a place of challenge and of salvation. For 4000 years, people have puzzled over its meaning and emerged not a lot the wiser. When I started to write this book I was hoping to produce a simple, concise picture of its history, but instead I found myself immersed in a maze—an inextricable one of double meanings and meanings within those meanings. The deeper I dug, the more complex the maze became. In the end I decided that the only truth about the labyrinth is that there is no one truth. Ambiguity, complexity are part of its essence.

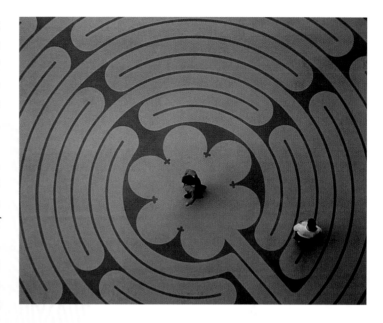

Above: A path of endless twists and turns, outdoor labyrinth, California Pacific Medical Center, San Francisco, U.S.A.

The Labyrinth is a riddle
It is the cosmos and the world
The life of human kind, the womb of the earth
The journey, the way to the center
The way to ourselves ...
— Ursa Krattiger Tinga

History presents it as a place of contradiction: of hope and fear, light and dark, beauty and danger. The labyrinth resists our attempts at definition, which is just as it should be, perhaps. As the late American mythologist Joseph Campbell says, so do all great symbols and archetypes. They speak to us not directly but via the language of poetry, through metaphor and multiple layers of truth. The same may be said of important myths, and the labyrinth is nothing if not a great, long-running myth that has tantalized us for millennia.

Above: A puzzle maze, like this one in a London subway station, has many paths and dead ends, while a labyrinth (below) has just one continuous path—earthwork labyrinth, California.

Archaeology dates it back to the Bronze Age, when simple seven-circuit models began showing up in Europe, the Middle East and parts of Asia as carvings and drawings on clay tablets, stone walls and coins, later as designs for mosaics, house decorations and manuscripts. Greek and Roman mythology present it as a building of awesome dimensions and inextricability: a prison, but also a place of rebirth and protection. Popular during Roman times, it reached its peak during the medieval period when elaborate 11-circuit models appeared as mosaics on the paved floors of churches and cathedrals across France and Italy as well as in the fields of Britain and Germany.

My first encounter with a labyrinth came in 1997 when, on a sunny afternoon, I wandered into San Francisco's Grace Cathedral and saw one on its floor. Immediately I fell in love with its eerie beauty and elegant geometry, which of course is how labyrinths usually get us in—they are attractive to the eye, works of art. Apparently simple, they hold within their coils complex secrets of design as well as of meaning. We should never be fooled by their simplicity, however, for they are undoubtedly chthonic, devices for going deep, for plumbing the mysteries of the soul. This is in keeping with their ancient associations with the underworld, the awesome place of death and rebirth. For me, there is an important message in this underworld aspect of the labyrinth. A walk in its winding path can indeed be a journey inwards, an excursion into deeper layers of consciousness. As many of those interviewed for this book report, it is a journey that can produce sudden insights and challenges. These can lead to profound transformations, though not without struggle. Maybe in the stories about the labyrinth we can find guidance as to how to better deal with such struggles and how not to get lost in either our private or public underworlds. Could this be the path's most useful contribution to our times?

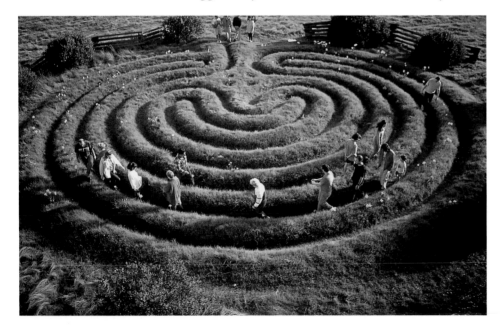

Since 1997 I have undertaken research into the labyrinth's history and the ways in which it has been viewed over time. This book is the result of that effort. In the first chapter, 'Gateway to the Heart', I delve into the many aspects of the labyrinth's meaning and why it especially appeals to us now, here at the beginning of the 21st century. After this comes a history—not a definitive one, but a thematic history, the story of our ideas about the labyrinth from the Bronze Age

Left: Complexity in the guise of simplicity: Bath Festival Maze, Beazer Gardens, Bath, England.

onwards. In it I think I have managed to uncover some new clues about its meanings. Finally, I take an in-depth look at the modern movement and the many extraordinary ways in which labyrinths are being used today, as tools for spirituality and meditation, creative play and for connecting us with the mysteries of nature.

This book is intended to be a guide for the aficionado and the novice alike, for lovers of art, indeed anyone intrigued by a good mystery. In it, I have included a 'Pilgrim's Progress', a guide to some of the world's most beautiful pathways, so you can experience their magic for yourself.

The labyrinth's re-emergence poses many interesting questions about who we are and where we are going. History shows that it crops up in times of change and breakdown in traditional social and religious structures. Over and over again, it appears as a device for protection and guidance in times of difficulty and struggle. Today, in awakening us to our deeper humanity, our 'hearts', it has the possibility—so some people think, anyway—of becoming a tool for peace which can encourage tolerance and understanding—important functions in a crowded, busy world.

Diversity is the essence of the labyrinth, even though it has just one path. For some it is a road to 'truth'—but what kind? In our rush to embrace this ancient device, we should be careful, I think, that we do not limit it and turn it into a 'One True Path' of belief, no matter how beguiling and innocent that belief might seem, for it has never been a platform for dogma. Its meaning has changed from era to era.

Indeed, one of the best things about labyrinths, I believe, is that they teach us to laugh at any idea of absolute truth (or at least dance with it), as the Italian author, Umberto Eco, says. As devices of complexity, with many shades of meaning, as doorways to mystery, they have the power to draw us in and show us much about ourselves, the world and about truth too. So let us now enter the world of labyrinths and explore them as works of art, elegant puzzles and as gateways to the heart.

1. GATEWAY TO THE HEART

I felt relieved and awake. I believed in my feelings … I realized there was nothing to be ashamed of, just because I am a child doesn't mean I can't do it. I spoke out my words in my mind. I gave it away to god. He took care of it and threw it far from me. This helped me and took those feelings away … and solved my problems — Kimberley (9 years old, in her own words)

In May, 1998, I was teaching a series of classes on the labyrinth in New Zealand when the girl who wrote the message above turned up to walk the path. Straight away, she struck me as an unusually serious child. Unlike others who came that day, she moved slowly and deliberately, and her attention never wavered from her task. I sensed that she was troubled about something. Afterwards, reading what she had written, in the journal of comments I kept beside the labyrinth, I got my first inkling about why this ancient device is coming back just now and why people in Western societies seem so keen to explore it again. To my mind, her note summed up the essence of how the labyrinth is being seen and understood, in certain parts of the West anyway, and I decided to start my story with it.

First of all, she talked of believing in her feelings. In our overly rationalist, materialist world, we are taught to mistrust our emotions, our hearts. Feelings are dangerous, we are told, they interfere with the acquisition of wealth and are a sign of moral and spiritual weakness. How liberating—or, alternatively, confronting—it must be, then, when people enter a labyrinth and discover that it can be, first and foremost, a journey into their deepest emotions and thoughts, towards a center that symbolizes for them the 'heart' of all their experience. Within its lines, some report that they have a deep sense of connection—another word heard commonly in association with labyrinths—to a divine or transcendent force or with their own being or selfhood. These four words—feeling, heart, connection and selfhood—seem to sum up the essence of our modern fascination, spiritually speaking, with the labyrinth.

Opposite: In the center …

Below: The labyrinth in Grace Cathedral, San Francisco.

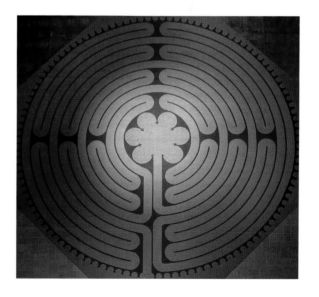

The next thing our young friend mentions is experiencing a sense of release and an easing of her problems. This, too, appears to be a crucial part of the labyrinth experience today for many people, who seem to enjoy walking the path because they come out feeling more peaceful and resolved about issues in their lives. For some, a labyrinth walk can even be quite cathartic and life transforming. There are numerous reports about people leaving behind fear, grief, depression, anxiety and addictions in its paths. How could a simple pattern, a few lines drawn on the ground, elicit such varied and powerful responses?

Many people like to think of the labyrinth as a spiritual device, but it is really a symbolic device, a metaphor, even a multi-dimensional poem, perhaps. It can be interpreted in a spiritual way, certainly, and is most commonly, but that is not what it is in essence. In saying this I do not mean to imply that it has no intrinsic spiritual value. The labyrinth is simply first and foremost a symbol, just as a cross or a spiral is, and as such, it can be interpreted in a myriad of ways. Its meaning today is not what it was in medieval or Roman times, and may not be its meaning 200 years from now. How we choose to interpret it, however, tells us a lot about who we are and what we are seeking. What does the labyrinth tell us about our needs right now? Let us look in more detail at the ways in which it is being interpreted.

Metaphoric Meanings

To begin with, for many people today, the labyrinth symbolizes a *way in*, a single clear path into an interior reality, a track through the layers of their consciousness, past the confusion and chaos of the daily world. We should not underestimate the power of this metaphor. A path, like a door, is very seductive; it offers the promise of excitement and new discoveries but also of guidance in times of trouble, a way through the maze of life. It gives us the hope that we are going somewhere even when we cannot see the destination. It offers an initiation into new mysteries. Like Alice in *Alice in Wonderland* and Dorothy in *The Wizard of Oz*, we find it very hard to resist doors or paths.

The labyrinth also has a center, symbolizing wholeness and completion, the heart of the matter, our human heart. In one of the most popular models today, this center is shown as an open flower, a rose, a symbol for the heart down through the ages. When we are in it, we can see the big picture—

Below: With its flower-shaped center, the Chartres-style, 11-circuit labyrinth is the most popular model today— garden labyrinth, Sparrow Hospital, Lansing, U.S.A.

the pattern of our life laid out all around us. We can see where we have been and where we are going next and who is on the path with us. Sometimes, if we fully enter the realm of the heart, we can even reinvent ourselves, change direction and connect to our deepest level of being, our souls. The center is where we see ourselves most clearly, and sometimes where we connect most deeply to others.

Finally, the labyrinth offers us a *way out*, a path of rebirth and renewal, perhaps the most powerful metaphor of all. Those who choose not to walk the path back to the entrance but exit the labyrinth directly from the center sometimes miss this all-important experience, for the way out can be as powerful as the way in. It allows us to come to terms with what we have learned and what we may become. It shows us possibilities and sometimes it gives us our best insights. Many of us long for an opportunity to start over in life, to be 'born again.'

Guidance, peace, transformation, connection, inspiration, spiritual journey, hope—these are the words that people around the world are using to describe their experiences inside labyrinths. Today, the 4000-year-old device, which began its life as a simple drawing on pottery and stone, is being viewed primarily as a gateway to the heart. Of course it was always a gateway of one sort or another—to the underworld, the city, the temple, the home, the church. Labyrinths have a strong tradition as magical, protective devices and symbolic entrances. They guard the doorway between the profane outer world and the sacred inner one. Nevertheless, we need to realize that our current psycho-spiritual

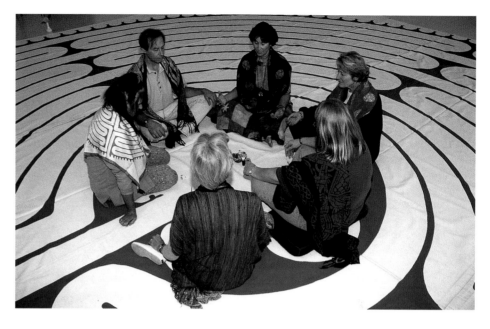

interpretation may be rather new. Labyrinths were not always devices for inner peace or spiritual comfort. Indeed, they may have had an opposite purpose in past eras, as you will see.

Group meditation in a labyrinth, California, U.S.A.

A Tool for Change

In spite of this, the labyrinth's potential today for creating spiritual 'openings of the heart' and even major breakthroughs seems to be considerable. Many report that working with the path has changed their lives. The president of the global Labyrinth Society, Helen Curry, of Connecticut, USA, is one of these. From being a housewife, she is now a full-time labyrinth facilitator and interfaith minister who conducts weddings within labyrinths and regularly takes one into a Federal prison to work with inmates. In her book, *The Way of the Labyrinth: A Powerful Meditation for Everyday Life*, she reports that the first time she encountered the pathway, in a workshop in 1993, tears came to her eyes, such was its effect on her, and from then on she was 'hooked.' Since setting up her non-profit corporation, the Labyrinth Project of Connecticut Inc., she has conducted workshops in the U.S.A., Russia and Lithuania, and has built several labyrinths herself. Says Curry: 'No one can prepare you for the effect on your life. It changes everything … *everything*.'

On the other hand, we should not underestimate the other side of this process. Those who work closely with labyrinths talk about sudden confrontations with difficult truths or with grief. They also mention headaches and feelings of tiredness (alternatively, heightened energy) or strong emotions. Most facilitators can report at least one incident of someone entering a labyrinth and bursting into tears or laughter … or falling into long, deep silence. As we shall see, there is a profound mystery surrounding these ancient pathways—about death, rebirth and the underworld—which might account

To all who stand here at your portal, Lady Labyrinth, I send you greeting. Do you tremble, part in fear, part in longing? … Entering a mystery is an act of courage, I salute you.
— *Joyce Gibb*

15

On a cold night in Ottowa, Canada, labyrinth keeper, Ruth Richardson, swings by her church around midnight and sees a man shoveling snow from the top of the newly laid labyrinth. Inquiring gently as to why he might be out so late, she hears that he is clearing the path so that his wife, who is ill and cannot sleep, can come and walk. It helps to keep her relaxed and calm, he says. Later he leaves the brand new shovel behind so others can clear a path if they need to. It stays there until the end of winter, encouraging groups of people to come and walk, even in the snowiest conditions. In a place that is normally deserted, Ruth begins to notice more and more people coming to chat and help with the snow clearing around the labyrinth. A feeling of camaraderie and common purpose develops.

In the town of Scheidegg, Southern Germany, a Lutheran minister, the Rev. Peter Bauer, finds himself in the midst of a profound personal and professional crisis. Feeling spiritually 'dry' and stressed, he cannot cope with his life as a parish priest any more so he and his wife Monika decide to go on a pilgrimage, in his words 'in order to let go of the old and make way for the new.' They walk from Scheidegg to the shrine of St James at Santiago de Compostela in Spain, around 1000 miles. On their way, they come across many labyrinths but especially the one in Chartres, France. Here Peter has a profound experience of the merging of his inner and outer life as he notices the way that the symbolic path of the labyrinth mirrors his pilgrimage. Then he realizes that 'you just have to keep going and you will surely find your way to the center.' It is a turning point. When he and his wife get back from pilgrimage, he is ready to resume his ministry. He and Monika build a labyrinth for their Church of the Resurrection in Scheidegg. In its center he places a stone, in the form of a cross, that he found on his journey through the Swiss Alps.

In a county jail in Monterey, California, the chaplain, the Rev. Deacon Peggy Thompson has been arranging regular labyrinth walks for inmates but one young man is not so sure he wants to try the strange-looking device. 'What's this … what'll it do for me?' he asks, a look of suspicion on his face. He has been in and out of jail since he was a teenager, and after one more arrest, he is angry and in a blaming mood. He decides to give the labyrinth a try anyway but goose steps part of the way around the path, missing the center, so he arrives back at the beginning. 'What went wrong with that thing? It spit me out!' he complains. Peggy gently urges him to try again. This time he reaches the center where, much to her surprise, he bursts into tears. For 10 minutes he sobs uncontrollably. Later he tells her: 'Help me. I don't want to spend my life in jail.'

At a rock music festival in eastern Australia, a labyrinth has been placed inside a tent for revelers to walk when they need a break from the music. Throughout the day there has been a steady but small stream of young people coming to try out what is seen as 'that labyrinth thing.' Many have been experimenting with drugs but they seem to appreciate the quiet and peace of the labyrinth tent. Some leave a small donation, others nothing at all. Late in the evening, a facilitator notices a young woman walking the path in a way that seems unusually focused and intense. Afterwards, when the woman has left, she finds $50 on the table and in the labyrinth diary a brief note: 'An amazing experience,' it says simply. 'I sensed a presence here, very strong … thank you.' A little later a young man leaves another message: 'I thought I had reached the end of my spiritual journey. Actually I have just taken the first step …'

for some of the experiences that people have reported. While such mysteries make some current enthusiasts uncomfortable, it may nevertheless be wise for us to fully explore the labyrinth's meanings through history in order to understand its effects on us today.

Other Uses

Labyrinths are being used in other than spiritual ways, of course. Currently they are appearing in prisons, hospitals and drug treatment centers, especially in the U.S.A., as tools for healing, therapy and rehabilitation. Social workers, counselors and therapists are using them to open up dialogue with clients and get to the root of problems related to abuse and antisocial behavior. Many report that the pathways are especially useful for dealing with the wounds created by abuse during childhood. Hospitals are utilizing them as part of cancer treatment and palliative care programs and as a way for staff and patients to 'de-stress.' In schools they are being employed in art and personal development programs. All of these are dealt with in more detail later in this book.

Labyrinths are also appearing as platforms for dance and theater and as vehicles for artistic expression and play. Like the circular arena where Greeks performed in ancient times, they seem to make excellent stages for seasonal and communal celebrations and for bringing people together. This is especially so in Europe, where there is a much more secular and artistic tradition surrounding them. Labyrinths are, indeed, highly theatrical creatures. They love the limelight, and with their hypnotic rings, they draw all eyes towards them. What better place, then, to act out our creative fantasies?

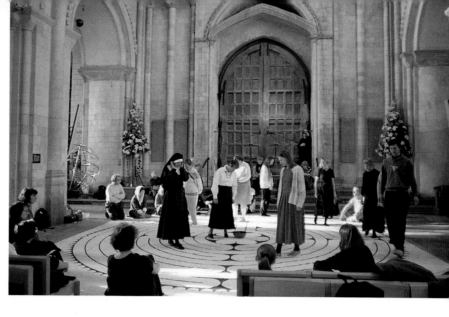

Above: Labyrinth walk in England. In 1997, London teacher, Helen Raphael Sands, began a three-year program of walks to lead up to the new millennium.

Below left: Dancing in a labyrinth, California.

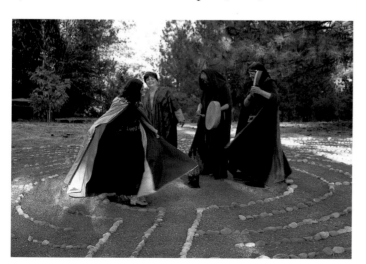

There is one other way in which they are being used, and that is in re-establishing our fragile connection with the natural world. Lovers of nature, neopagans and dowsers are using them to connect to what they see as vital streams of energy contained within the earth—for divination, healing and 'eco-spirituality', or nature mysticism. In some places the labyrinth has become a powerful symbol for the cosmos and for the ancient earth goddess, worshipped since Neolithic times.

'You are really yourself, even in a crowd in the labyrinth ...' — labyrinth walker

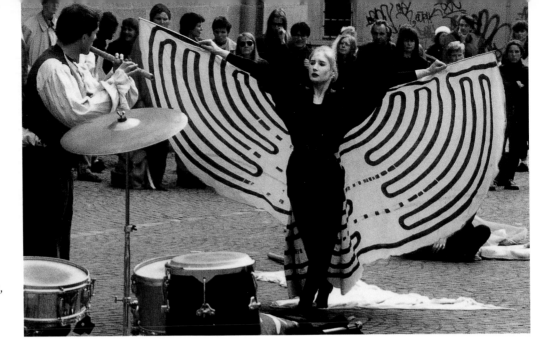

Right: Performer with labyrinth wings, Zurich, Switzerland.

'The walk started slowly, deliberately. I asked my questions and got my answers. Every time I stood for a moment or two … I could feel the energy come up through the soles of my feet. Towards the end I began to feel at one with the pathway. Some unexpected answers came through …'
— labyrinth walker

Why Are They Coming Back?

There appear to be a number of important social reasons for the labyrinth's return. In the West we live in affluent but lonely times. Mobility, dislocation and upheaval are at their highest levels ever, according to researchers, and social isolation is becoming the number one problem of our cultures. In his book, *Bowling Alone: The Collapse and Revival of American Community*, a Professor of Social Policy at Harvard University, Robert Putnam, points out that Americans have never been so disconnected from their institutions, communities, families and friends. Many do not campaign, play bridge or even talk to each other, he says. Rates of social participation in everything from family dinners to club membership are down by 20–60 percent, compared to just 25 years ago, resulting, he suggests, in higher crime rates as well as higher rates of suicide, depression and illness. Putnam paints an image of modern Westerners as self-obsessed loners, commuting between their offices and TV sets, too busy and tired to invite the neighbors in for a drink or help out with a local project. 'Connection', or rather the lack of it, seems to be a major issue. Today, among their other uses, labyrinths appear to be emerging as community-building tools. In this context, it is interesting to note that the last era in which communal breakdown was a major problem, the late 19th century (according to Putnam), was also a time of revival in labyrinth building in some places. Social breakdown and the path seem to go together.

Labyrinths appear to make very good meeting grounds. Indeed, one of their more interesting features is the way they bring together people from all walks of life and faiths: Christians, Moslems, Jews, Buddhists, Neopagans, New Agers and those with no beliefs whatsoever. Within a labyrinth you are likely to encounter people who believe in meditation, prayer, crystals, karma, angels, spirits, Jesus, Buddha, Kali, Allah, God the Father, God the Mother, Science and no god at all. A fellow walker could be a corporate manager or someone who is homeless; a doctor, teacher, student, artist, poet or priest;

someone who is happy or hurting, mad or sane, educated or illiterate. Unlike on our streets, it is hard to ignore those we meet in the labyrinth's coils. The path turns endlessly back upon itself, forcing us to confront the 'other', the stranger we see in front of us, in whose features we sometimes recognize ourselves. The process is one of constant mirroring, back and forth. In short, the labyrinth is a place of encounters.

Another reason for its return may be found in our apparent desire for alternative venues for religious or spiritual expression. Many in the West have fallen out of love with the churches of their birth. This is perhaps less the case in America, where rates of church attendance are still the highest in the Western world, but it is certainly so in other countries. Many who come to labyrinths nowadays do so because they see them as non-religious 'spiritual tools'—non-denominational, non-dogmatic and 'safe.'

There is one final issue which the labyrinth seems to address, although it is more nebulous: the problem of soul. We live in soulless, heartless times. Ask anyone—which of course might explain why we are so preoccupied now with the very words, 'soul' and 'heart.' Take a look at the shelves of your local bookstore and see if you can count the number of titles with these words in them. Just as poetry and storytelling festivals are coming into vogue, so too is the labyrinth, and for the same purpose: it seems to connect us to soul, to the deepest realm of feeling.

In the course of research for this book I asked everyone I spoke to a couple of questions: *what do you think the labyrinth is for?* And *why do you think it is coming back?* I got as many answers as there are labyrinths. 'What is it for?' received replies as varied as meditation, celebration, spiritual connection, talking to God, talking to spirits, self-exploration, healing, sensing 'energy', wisdom, worship, divination, inner peace, forgiveness, transformation and communicating with others. 'Why is it coming back?' elicited responses such as a need for more spaces for communal gathering, spirituality, earth and feminine-centered spirituality, places of healing, places of peace and places for connection to others. Some

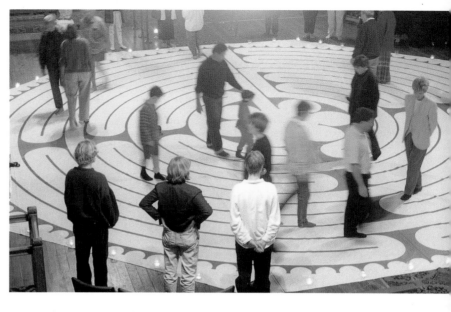

Above: A tool for community—Labyrinth walk in New Zealand.

Below left: Boy in a labyrinth, England.

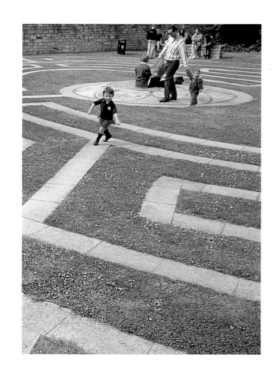

'Tension and self-absorption slid away from me as I walked … suddenly I found myself in the hub of the labyrinth and I wanted to stay forever. Utterly peaceful and deeply "rinsed", I sat in that extraordinary calm emptiness.'
— labyrinth walker

Above: Nature worshippers in a labyrinth, California.

told me that God or the Goddess had sent the labyrinth back into the world, some said it was nature's way of speaking to the planet before it is 'too late.' Others said it was just 'an idea whose time has come again.' The simplest answer was: 'Because we need it.'

French social historian Jacques Attali, author of *The Labyrinth in Culture and Society*, thinks the re-emergence of the labyrinth represents a shift from 'linear' modes of thinking to more circular or web-like ones. As he points out, Western culture has gone from seeing science, history and politics in terms of simple 'phallic' models of progression from chaos to order to adopting more 'wholistic' notions of interaction and connection, symbolized by the complex artistry of the labyrinth.

American Labyrinth Society President Helen Curry believes the labyrinth is a 'path to the Divine within.' She also sees it as a tool for change and transformation and thinks its return is a sign of a general community reawakening to 'Spirit.' Robert Ferré, of the U.S.A.-based St. Louis Labyrinth Project, says the labyrinth is a way of 'tapping into forces beyond our normal conscious mind. It takes us to some ancient part of ourselves … when people knew the sky and nature was a part of us and we of it.'

Helen Raphael Sands, London-based labyrinth facilitator and author of *The Labyrinth: Pathway to Meditation and Healing*, says the path has wide appeal because it represents a 'neutral symbolic form, free of specific religious connotations.' Susanne Kramer-Friedrich of the Switzerland-based Labyrinth Project International, thinks that labyrinths come back in 'periods of lost orientation and perspective.' Finally, Jeff Saward, editor of the British journal of labyrinths and mazes, *Caerdroia*, thinks the labyrinth's return has to do with the fact that we live in a time of rapid change, especially technological change. He sees labyrinths as metaphors for uncertainty, but ones which assure us that if we 'stick to the path, we'll get to the goal.'

The Path of Life

Perhaps the most compelling reason for the labyrinth's popularity now, however, is to be found in its capacity to allow us to see ourselves for who we are and, more importantly, to accept what we see. Many people enjoy finding metaphors for their lives in the pattern of the labyrinth and their experiences while walking it. The best example I had of this was a woman who came to me after a walk and recounted how at first she thought she was lost because she just kept 'going around in circles.'

'It felt like my life, endlessly going backwards and forwards and getting nowhere,' she told me. But then she reached the goal and all of a sudden realized: 'This is what life is like. You go round and around on what looks like the same old path but really you are on a journey. If you keep going, you reach the

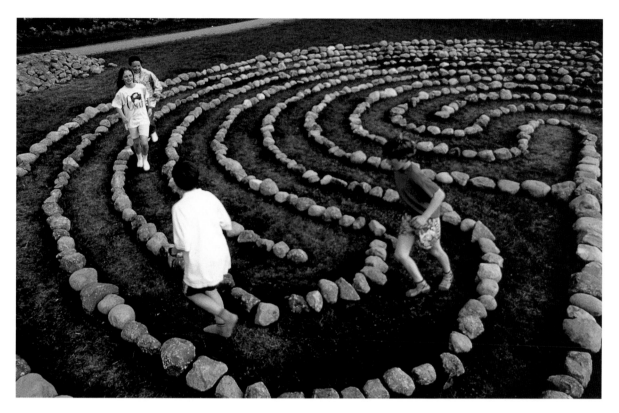

Left: Children running in a labyrinth at a holiday center in Tisvildeleje, Denmark.

center.' I have had other people tell me that they have learned a lot about themselves from their encounters with fellow walkers. How they pass or are passed and how they feel at close proximity to strangers gives them clues about their relationships with others. Some recoil, some enjoy the interactions.

Walking a labyrinth is a *kinesthetic* meditation. You do it with your whole body, which many enjoy as an alternative to other forms of meditation or prayer, which tend to be more 'in the head.' Also, labyrinths are creatively stimulating and just plain fun. Women like to dance in them. Children enjoy running. Men seem to enjoy experimenting with unusual steps and postures—skipping, crawling, putting one foot neatly in front of the other, practicing Buddhist walking meditation styles and lying down on the paths and in the center. Music can enhance the experience, although some people prefer silence. A labyrinth walk is also an aesthetic experience. The look of the path, its design, the setting and lighting, the artwork placed around it all play crucial roles in determining the nature of the experiences people will have. The invention of new labyrinths, and particularly experimentation with three-dimensional models in holograms and other light forms, promises exciting developments for the future.

Overall, the labyrinth appears to have become, for many people today, a kind of 'universal spiritual tool.' In order to understand more about it and why it is having such an impact on us, we need to look at its history. Our initial exploration will take us back 2800 years to Iron Age Greece and the emergence of the very first story about the labyrinth: the myth of Theseus and the Minotaur.

'A sacred communion with God, peace and understanding unfolded—dancing in the silence and between the notes, my soul has been moved and opened to a new experience of wonder ... thank you.' —labyrinth walker

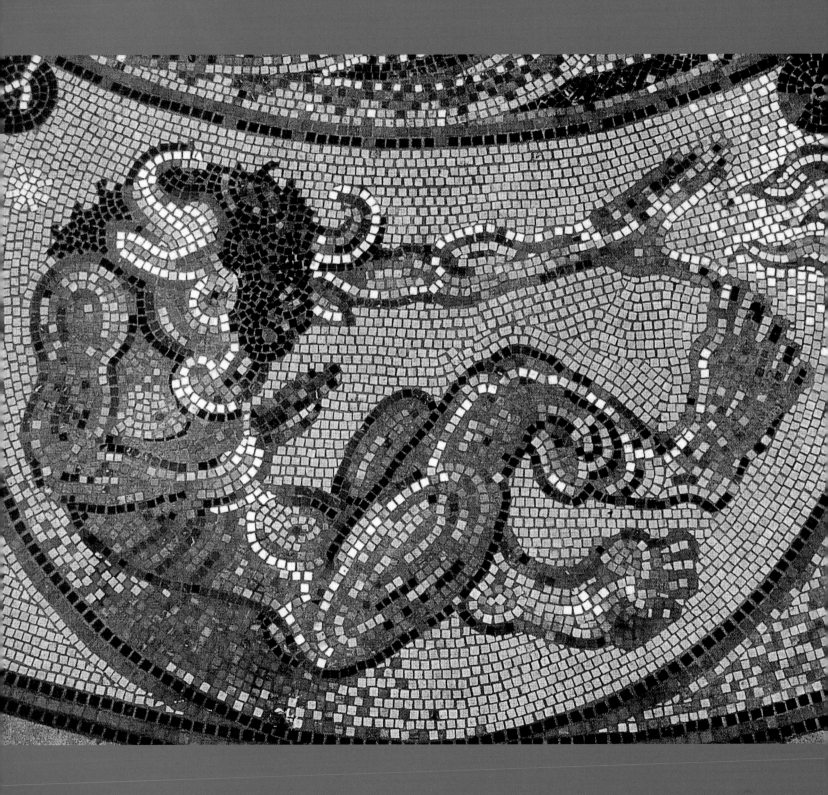

2. THE GOD IN THE LABYRINTH

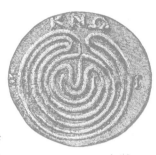

Him of the plains why have they slain?
The shepherd, the wise one, why have they slain?
The man of sorrows ... why have they slain?
— *Ishtar's lament for Tammuz*

At the heart of the labyrinth lies one of the most profound mysteries of the ancient world—the story of a sacred marriage between a god and goddess and of death and resurrection in the cave of the underworld. The clues to this mystery are to be found in the oldest story about the labyrinth, the one written by Greeks in the eighth century BCE and rewritten by Romans from the first century onwards—the story of Theseus in Crete. In it we discover a monster called the Minotaur, half man, half bull, trapped inside a prison so intricate and fearful that no one can escape. The myth presents the labyrinth as a maze of terror and death, where every nine years, seven men and seven maidens are sacrificed to the monster, who has been born, we are told, of an unnatural union between a Queen of Crete and a white bull (see story next page). It takes a hero, Theseus, a magician, Daedalus, and a woman, Ariadne, to defeat him and effect escape from the labyrinth.

What are we to make of this strange story? On the surface it is a standard Greek tale about power, kingship and heroic deeds as well as a salutary lesson about the dangers of illicit passion. Politically speaking, it probably aims to show us how the Greeks were superior to the Cretans (who had dominated the Mediterranean until around 1500 BCE) and to establish Theseus as a monster-slaying hero and future king. Usually commentators focus on Theseus as the central figure, but for our purposes we are going to look at the other key characters in the story: the Minotaur and Ariadne.

Why? Well as you are about to see, underlying the so-called 'Cretan myth', is a much older and more interesting story that dates back to around 2600 BCE and probably further, about marriage between a goddess and a god and about descent into the underworld. By understanding it, we come to see much more clearly what the labyrinth might have symbolized in the minds of the people who first used it.

The earliest version of this myth is recorded on clay tablets in Sumer dating from the third millennium BCE. It tells of a goddess, Inanna, and her consort, Dumuzi, known as the 'wild bull.' Bulls seemed to have been important symbolic animals to our forebears. We see them as early as the Paleolithic era, painted on the walls of caves in France and Spain, then, in the Neolithic period, on stone and clay tablets from Sumer and the Indus Valley, as well as in ritual vessels and decorations from Anatolia (Turkey) and Crete. By the Bronze Age, a bull-like man or god (it is not clear which) has become the son or consort of a goddess and sometimes he is also a king. His horns adorn the goddess's temples, his gilded features are carved into harps and ornaments.

Above: Labyrinth coin from Crete, third century BCE.

Opposite: Minotaur mosaic maze from Bath, England.

Below: Bull image from the Paleolithic era, Lascaux, France.

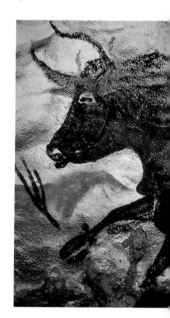

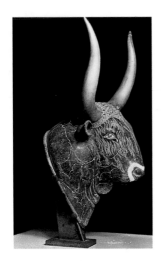

Above: Bull rhyton, Crete.

In the Sumerian story, Dumuzi, the 'wild bull', is sent down to the dreaded *Kur* (underworld); while he is there, Inanna mourns bitterly for him. After six months, roughly the period between late summer and spring, he is allowed to return. The story is repeated in Babylonian mythology with the death and descent of Tammuz, beloved of the goddess, Ishtar. Next, from Egypt, comes the story of Isis and Osiris, in which the god Osiris is slain by his jealous brother Set. Isis goes in search of him and when she finds him, she conceives her son, Horus, using the dead king's phallus. Later, Osiris is resurrected and becomes the Lord of the Underworld. Similar gods and heroes of death and resurrection appear all over the Mediterranean and Near East: Adonis (Syria and Greece), Attis (Anatolia), Orpheus (Greece), Mithras (Persia and Rome) and finally, of course, Christ himself.

At its simplest level, this story of death and resurrection is an analogy for the seasons. The god grows to manhood in spring, reigns in summer, descends and dies in the Fall only to be reborn again around the time of the winter solstice. At a deeper level, however, it stands for a fundamental truth of existence, that only from the death of the old can new life arise. Just as farmers know that compost and fallow periods are essential for productive fields, so our forebears apparently believed that the god/king who represented fertility needed to die each Fall. The bull was seen as the seed of life, a perfect symbol of strength and virility, as well as of kingship. His blood renewed the earth. Often our ancestors enacted his death with the sacrifice of a living bull; at other times they portrayed it symbolically by placing an effigy of the dead god/king on a boat and sending it down a river; in rare cases, human sacrifice was practiced. From Greece comes a clay tablet showing two bulls with plants growing out of them, a clear indication of why such sacrifices were considered necessary.

Within Cretan culture, the story of the bull god's death and rebirth seems to have been well known, judging by the proliferation of frescoes and cultic objects representing bulls and bull sacrifice, such as the beautiful *rhyton* or ritual vessel with gilded horns (left) unearthed there. The animal's horns, in Crete particularly, seem to be associated with kingly power. Indeed, it is thought by

Above: Rock art depicting a bull with spirals, Spain.

Right: Theseus and the Minotaur (panel), by Master of the Campana Cassoni (fl. c. 1510), Italy.

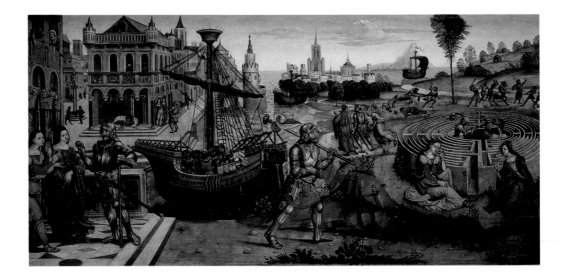

THE STORY OF THESEUS AND THE MINOTAUR

From the sea, Poseidon sent to King Minos of Crete a magnificent white bull. The King should have sacrificed the animal to the god but he decided to keep it and killed another in its place. When Poseidon saw this, he punished Minos by making Pasiphaë, his wife, fall in love with the bull. Unable to control her desire, she found a way to mate with the beast and so gave birth to a son, half human and half bull, who was called the Minotaur. When Minos saw what had happened, he had the monster imprisoned in a maze called a labyrinth, which was built for him by the architect, Daedalus. Every nine years he exacted a tribute from Athens of seven youths and seven maidens to sacrifice to the Minotaur in the labyrinth. One year, Theseus, the son of the king of Athens, vowed to slay the monster and volunteered to become one of the men to be sent to Crete. Arriving on the island, he was greeted by Ariadne, daughter of Minos and Pasiphaë, who fell in love with him and offered him a ball of golden thread with which to find his way out of the labyrinth. Armed with that and a spear, Theseus slew the Minotaur and escaped the maze. He and Ariadne then fled to the island of Naxos, where he abandoned her, before heading back to Athens to become king.

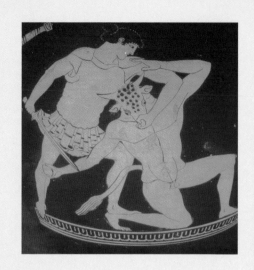

some scholars that the story of Theseus alludes to a Cretan rite of kingly initiation in which a king killed a bull as a representative of himself, for the ritual descent into the underworld.

After the collapse of Crete, around 1500 BCE, many of its stories and myths became incorporated into the mythology of the more patriarchal civilization of Mycenaean Greece. The bull god, too, was assimilated among Greek deities—Zeus, Poseidon and Dionysus—each of whom took bull form from time to time. By the eighth century BCE, however, when the Theseus story was written, the bull god had been downgraded into a 'monster' who had come into existence as the result of an act of greed. King Minos refused to offer a white bull (the Minotaur's sire) as a sacrifice to Poseidon, mainly because he wanted the animal for himself. The god punished him by making his wife, Pasiphaë, fall in love with the creature, and as a result, she gave birth to the Minotaur.

The British scholar Robert Graves was the first to point out, in his epic work, *The Greek Myths*, how the figures of Pasiphaë and the bull in this colorful story probably represent ancient primal gods of sun and moon. Pasiphaë, whose name means 'she who shines on all', was a Cretan moon goddess, as was her daughter, Ariadne, whose name translates as 'holy and pure', according to Graves. Ariadne was also a name for the Cypriot goddess, Aphrodite. As Graves then concludes: 'The myth of Pasiphaë and the bull points to a ritual marriage under an oak, between the Moon-Priestess wearing cow's horns and the Minos king wearing a bull mask.'

Above: Theseus and the Minotaur, Greek vase, sixth century BCE.

Below left: The Minotaur in the labyrinth, 18th century engraving.

Below: Cretan coin showing a square labyrinth, fourth century, BCE.

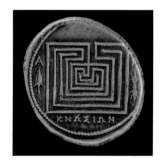

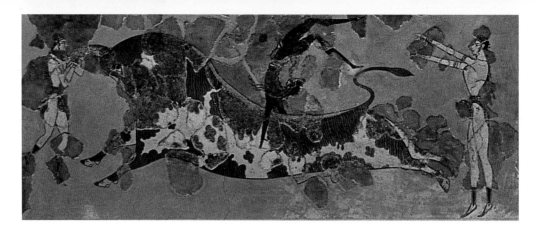

Right: Fresco of bull leaping, Palace of Knossos, Crete.

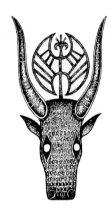

Above: Bull head with double axe.

The Minotaur's other name, Asterius, meaning 'starry', hints at his divine status too. Many gods of the ancient world, including Osiris and Isis, were closely associated with stars. The bull was to be seen in the constellation of Taurus. Graves tells us that Asterius is derived from Asteriaë, the goddess who created the seven planets, as they were known then. Because the stars were also associated in Greek and Roman minds with Fate (much as they are still today in the form of astrology), it is very likely that the myth writers were also letting us know that the Minotaur was Fate's representative too. In this light, the torturous maze-like path through the labyrinth, as described by the classical writers, becomes the path of Fate, which only a great hero could overcome. Why then did the Greeks portray the Minotaur as a monster? One explanation is that he was downgraded in order to erase the power his cult once held (and the power of the moon priestesses who, according to Graves, led his worship).

Apart from this, the story gives us important clues about the nature of the early labyrinth. There is a mysterious reference to Ariadne or someone like her as the 'Lady of the Labyrinth' on a Cretan Linear B tablet, dating back to 1200 BCE, a hint that the device may have been used for rites of worship associated with her marriage to the bull god but what form did it take? Many people who have taken the Greek story literally have gone searching for maze-like structures on Crete as the inspiration for

THE EIGHT-POINTED STAR AND THE 'DOUBLE AXE'

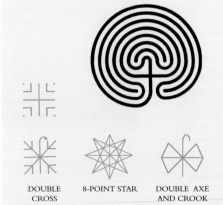

The labyrinth is created from a simple cross and four dots (see next chapter)—effectively, a double cross. From this can be drawn an eight-pointed star. Stars were associated with several deities in ancient times. The Minotaur, known as Asterius ('the starry one'), was often depicted with stars covering his body. The double cross also forms the basis for the famous Mediterranean 'double axe', found extensively on Crete. It is thought to have symbolized the waxing and waning moon, life and death. Lady Olivia Robertson, Spiritual Director of the worldwide Fellowship of Isis, believes that a double axe, overlaid by the crook of Osiris—a symbol associated with the god in his underworld aspect—can be found in the design of the early labyrinth. The four extremities of the axe correspond to the turning points of the path, and the top of the crook is the center of the labyrinth, she says. In Cretan art, double axes were carried by priestesses of a goddess. The crook, a possible symbol for the power of the underworld, appears in Egypt and in Neolithic tomb art as far afield as Brittany, France, where it is sometimes shown atop an axe.

DOUBLE CROSS 8-POINT STAR DOUBLE AXE AND CROOK

the labyrinth. The multi-level palace of Knossos itself is often thought to be the model for it. The word labyrinth is supposed to derive from a Lydian word, *labrys*, meaning 'double axe', a ritual object associated with Crete and especially Knossos but, as we will see, this is misleading. For a start, there is no evidence of any true labyrinth at Knossos. The palace is maze-like, but if we take a look at the first visual representations we have of a labyrinth—a clay tablet from Pylos dated 1200 BCE, which shows a simple square path of seven circuits (below)—we see that it is patently *not* a maze. There is now strong evidence that neither was the original labyrinth. In fact it probably signified something altogether different.

The Labyrinth and Dancing Grounds

Homer gives us a much better clue when he tells us that Daedalus, the maker of the labyrinth, built 'a dancing floor for fair-haired Ariadne.' This is not the only reference, and in fact dancing and Ariadne seem to go together. Was it possible that the labyrinth on Crete was simply a pattern for a sacred dance? In the Greek story we are told that seven men and seven maidens are fed to the Minotaur—a hint about Springtime fertility rites. The Roman writer, Plutarch, tells us that on Delos (the island at which Theseus also stopped after escaping Crete) he and his band of young men and women performed a ritual dance, called the geranos or 'crane dance' which may have mimicked the winding movements in the labyrinth. Given that the crane is a bird widely associated with the return of Spring throughout Europe, it is fair to assume that a dance in its honor, performed by young people, would have served the ancient purpose of ushering in Spring. Historians report that the residents of Delos performed the crane dance right through into Roman times, and today, a strikingly similar, labyrinth-like dance is still performed by the Basque people of Spain, according to the German art historian, Hermann Kern. Maypole dances, too, remain common in Europe; although altered by Christian custom, they serve an

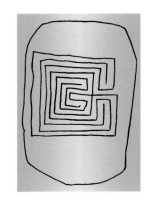

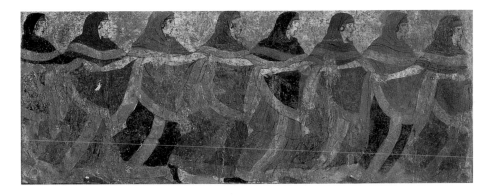

Top: The maze-like Palace of Knossos, Crete.

Above: Labyrinth drawing on clay from Pylos Greece, c. 1200 BCE.

Left: Women performing the funerary ceremonial chain dance, from an Apulian tomb, fifth-century (fresco).

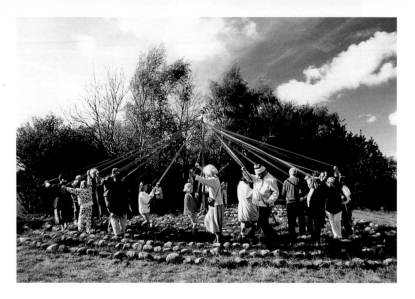

age-old desire to summon forth seasonal forces of fertility and growth and may be closely related to the crane dance. In modern Scandinavia, the maypole dance is sometimes performed in a labyrinth.

Kern, who was the preeminent modern historian of the labyrinth, was firmly convinced that the original labyrinth of Crete was not a building or even a three-dimensional maze, as reported by the myth writers, but a simple dancing ground. He pointed to much evidence for it in his masterwork, *Through the Labyrinth*. He suggested that a simple seven-circuit pattern was most likely drawn onto a courtyard of the palace of Knossos, to represent the path of death and rebirth, so important to the Cretans. Every Spring, a moon priestess, possibly named Ariadne, might have led or presided over a ritual dance of seven men and seven women to celebrate the union of god and goddess and the return of light and life after the darkness of winter.

Above: Maypole dancing on a labyrinth in Scandinavia.

Opposite: Wine jar from Tragliatella, Italy, seventh century BCE.

Below: 'Minotaur' by Picasso, 20th century.

Certainly the simple seven-circuit square and round labyrinths we see scratched on clay tablets, pottery and rock faces, dating from the Bronze Age, make more sense as a pattern for a dance than the vast, inescapable prison of Greek and Roman mythology. A further clue can be gained from an early drawing on an Etruscan wine jar from Tragliatella, Italy, dating from around 620 BCE (opposite), which appears to be mostly about the associations of the labyrinth with rebirth and sacred marriage, as well as with the Roman 'Game of Troy'—a ritual ride performed on horseback.

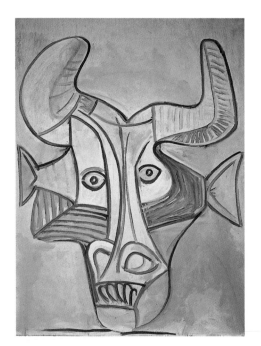

From this it becomes clear that underlying the story of the Minotaur is a much older myth about descent and rebirth that gives us real clues about the labyrinth's meaning in the ancient world. It appeaers that it began life not as a building or three-dimensional maze, but as a simple pathway for ritual and magical use and as a metaphor for the never-ending cycle of birth, death and regeneration. In succeeding chapters we will look at the various ways in which the labyrinth story has been interpreted throughout history—from the Bronze Age pagan view to the Graeco-Roman political, medieval Christian and our modern psycho-spiritual ones. Before we do, however, what of the Minotaur himself? What has happened to him in all this time?

The Minotaur's Return

Judging by the number of sketches and paintings he did of the minotaur, it appears that the 20th century painter, Pablo Picasso, was fascinated by this strange hybrid bull man. In almost every work, he portrays the bull with pathos, not as a terrifying monster but as a victim, the embodiment of human suffering. In one especially vivid image, the animal is being cruelly slain by a matador's sword. Picasso's images show us the

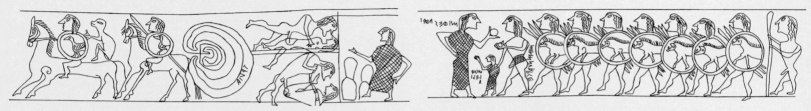

These scenes, depicted in a circle on the wine jar from Tragliatella (below right), may tell of the ritual marriage of a king and priestess and then his death and resurrection in a labyrinth. In the central scene (above right) the king with seven warriors behind him (echoes of Theseus's male companions) offers a priestess an egg while she, in turn, offers him what is thought to be an apple. Her stance is that of a dancer. According to Robert Graves, inscribed in letters beside the king is the phrase 'Winter, he rules' and next to her is 'pronouncing, she sets free', which suggests his emergence from the land of Winter (death). Next (left) we see the priestess gesturing towards two images of sexual coupling, followed by the labyrinth and two warriors emerging from it, one of them with an animal-like figure behind him (a creature from the labyrinth/underworld?). In the final image (far right) we see the king naked, holding a staff, a symbol of power. Then come the seven warriors and we are back to where we started.

Minotaur not as a monster, but as a sacrificial offering, symbol of suffering and a victim of humanity's relentless need to redeem itself through the death and pain of others. It is an image which is intended to awaken our compassion, perhaps.

The 12th-century theologian and scholar Peter Abelard saw much the same sort of role for Christ, whom he says came to earth not simply to redeem humankind from sin but to awaken in us the spirit of compassion for suffering and for all life. The message, radical for its time, got him into a lot of trouble with the medieval church. Of course no one in the Middle Ages would have gone for the idea of the Minotaur as the suffering hero in the labyrinth. Theseus had that role, but we must remember, warrior Theseus was never a god. As we have just seen, the real deity in the labyrinth is our mysterious, silent Minotaur.

There are some today who believe that the reappearance of the labyrinth represents the Minotaur's return too. In newly constructed pathways across America and Europe, the old gods and goddesses of our ancestors are again being honored in ritual and dance in everything from neopagan religious rites to modern performance art. For many, these nature gods seem to symbolize a spirit of reverence for the earth and its creatures, but more importantly, they also represent a connection to mystery and to our own humanness.

For others, the Minotaur is not a god but simply a symbol for that part of us which has the power to transcend and redeem our own suffering. Christ within. As the 20th century philosopher Bertrand Russell said, in violent, difficult and cynical times, the wise go inwards, seeking their happiness in contemplation and the cultivation of inner tranquility as well as detachment from material circumstances. Maybe this is what the Minotaur has come back to tell us and also, perhaps, to give us an idea about how to navigate the timeless mysteries of the labyrinth. What are the clues for this journey? Courage, love … and a little ball of thread.

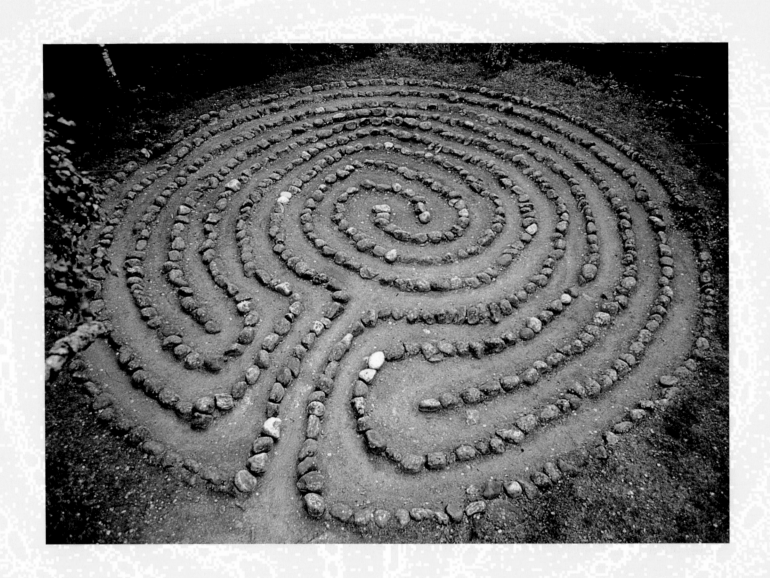

3. ANCIENT PATHS

Let us now leave the realm of myth and take a look at the real labyrinths of history. These are not the large walking-sized models in our churches and parks today, nor are they buildings with maze-like interiors, as mythology would have us believe. Rather, they are simple seven-circuit pathways created out of stones and drawings—small round or square-shaped graffiti scratched onto rocks, walls, pottery, door posts, clay tablets, rings and coins.

There is nothing puzzling or maze-like about the early labyrinth, which is made up of seven circuits and eight 'walls.' A single continuous pathway winds into its center. The walker progresses in a series of semicircles, first along the outer circuits and then the inner ones. The first datable appearance of this model is 1200 BCE on a clay tablet in Pylos Greece. However, the same design also shows up, around this time and later, in other parts of Europe, Russia, the Middle East, North Africa, Turkey, Afghanistan, Pakistan and India, South East Asia and, most surprisingly, in North and South America among certain tribes, prior to European arrival. Labyrinth-like spiral or circular patterns have also been found in Africa, Indonesia and Melanesia, as well as in the 'dreaming tracks' of Australian Aborigines. No one can say how or why the unique and distinctive seven-circuit pattern—identical wherever it appears—spread so widely, but like many symbols, it seems to have had an ability to cross cultures and times and to appear as if by magic.

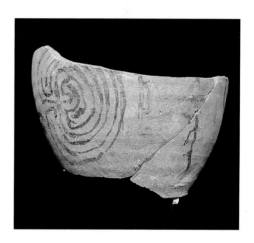

In the North of Europe—Denmark, Norway, Sweden and Finland, as well as nearby Russia—are to be found more seven-circuit labyrinths than anywhere else in the world. Hundreds of them, in stone, like the one from Finland, pictured left, still dot the landscape today. A few are thought to be ancient, Bronze Age or earlier, which begs the question: did the seven-circuit path arrive here at the same time as it did in the Mediterranean? Did it even originate here? There are no surviving walking-sized stone models from pre-Roman times in the Mediterranean, only carvings, which might lead us to this hypothesis. Was there a common source for all the labyrinths in the world? Some enthusiasts point to Siberia and the Ural Mountains as possible sources, perhaps because the meander pattern—believed by many experts to be the origin of the seven-circuit path—appeared in the Ukraine and in Siberia around 20,000 BCE. There is also a seven-ringed spiral dating back this far in Siberia. Some large paths, of indeterminate age, still exist in Northern Russia, up as far as the Arctic Circle.

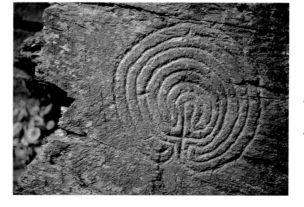

Above: Labyrinth image on a pottery fragment from Syria and, left, on a rock face in Cornwall, U.K.

Opposite page: Stone labyrinth in Finland.

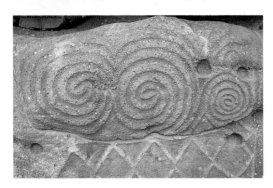

Above: Spirals at Newgrange, Ireland.

Below: Nazca pattern, Peru.

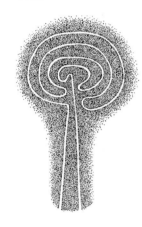

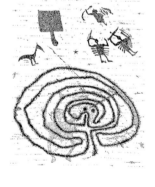

Above: Rock art, Val Camonica, Italy.

Right: Aboriginal painting, Australia.

While the exact origin of the seven-circuit labyrinth is unknown, it is speculated that it was developed from shapes much loved by earlier, prehistoric peoples. These are represented in their rock art dating back to the Paleolithic period (from 20,000 BCE). Spirals, meanders and figures made up of concentric circles, pierced by a line, called 'cup and ring marks' (right), are widely believed to be its forerunners. Of course a spiral is not a labyrinth but it seems reasonable to conclude that both it and the concentric circle are, at least, inspirations for the labyrinth. Meanwhile, the meander and the crooked cross or swastika (opposite page), an ancient symbol for the sun from India to Europe, are believed by historians to be of much more significance.

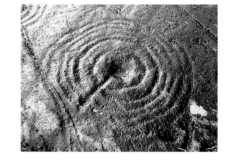

Early people used the earth as their canvas, sometimes drawing quite large-scale designs onto the ground. On a barren plateau in Peru, South America, can be seen some very large figures cut into the earth by the Nazca people over 1500 years ago, one of which is distinctly labyrinthine in appearance (left). It has been decided that these designs were walked for ritual processions in honor of the spirits they represented. Was this one of the first uses of a labyrinth, too?

The seven-circuit model is easy to make and to memorize, once you know how (see diagram on page 34), which might account for its wide spread. It can be quickly traced on the floor of a desert or a beach, in a forest clearing or on top of a hill. Formed from an equal-armed cross, it originally may have been a symbolic map of the heavens or of the sun's rotation across the sky, or it might have stood for a mythical cave, womb or serpent of creation. Among Australia's Aboriginal people there are stories of a huge snake called the 'Rainbow Serpent' (right) which, according to legend, gave birth to all other creatures. This snake is often portrayed curled up in a spiral or around a series of labyrinth-like concentric circles. Serpents feature prominently in Greek mythology, too, as symbols of immortality and prophecy.

At the other end of the scale, the labyrinth stood, in some places at least (as we have seen), for the perilous path of death and rebirth, in the same way that spirals and double spirals, which are also found all over the world, are thought to do. The famous spirals at Newgrange in Ireland (top left) and at the temple of Tarxien in Malta are believed by archaeologists to have symbolized the cycle of

A Prototype Labyrinth?

Shaman Krishna is from the mountains in Eastern Nepal, near the border with Tibet. Tonight he is performing a healing for a member of the study team, whom he says has had a hex placed on her since childhood. He promises to realign her 'grahas' or planetary forces. Onto the ground he and another shaman draw nine concentric circles representing the grahas; at its four compass points they draw Shiva's tridents. In the middle of the circles is a banana plant representing the world tree, to which the 'patient' is attached by a string tied to her wrist. There are also an egg and a chicken, which has been mesmerized into insensibility. The ceremony lasts for hours with much drumming, chanting and dancing. At several points Krishna dances wildly around the woman, brandishing sharp-bladed kukuri knives to separate her from her 'bad luck'; then he circles her with the chicken. At the climactic moment, the bird's head is severed, the string to the woman's wrist is cut, the tree is lopped down and the egg—now containing the curse, we are told—is crushed. The woman is told to quickly walk away from the circles and not to look back. She has been separated from her 'bad luck.' Afterwards, she reports feeling 'much better.'

life–death–rebirth. In rock art found at Val Camonica, Italy (left), the way *through* the labyrinth, known as 'Ariadne's thread', is what is shown, rather than the outline of the labyrinth itself. It might have been intended to illustrate the path taken by the spirit after death or simply to show the pattern of a ritual dance. On the other hand, it might have symbolized an important cycle. Like a spiral, a labyrinth is a perfect metaphor for the passage of seasons or the phases of the moon, of tilling, planting and harvest, stages of life and so on.

The labyrinth's practical nature—drawn large enough, it can be walked or danced—suggests many ritual, shamanistic uses, from simple imitative magic to vision quests, initiation, rites of passage and seasonal celebrations. As we have seen, in its very earliest stories it is closely associated with ritual dances, fertility rites and oracles, and with death and rebirth. During the Bronze Age, the Mediterranean and Middle East abounded in priests, healers, soothsayers and magicians, many of whom traveled from town to town, plying their trade and trying to outdo each other with new tricks and techniques. We get glimpses of them in the figure of Tiresias, the famous soothsayer of Greek mythology, and in various books of the Bible. Better still, we can see how a village shaman still operates today in modern traditional societies in Africa, the Himalayas, Siberia and South America. A few years ago I had an opportunity to spend some time with an anthropologist studying Nepal's shamans. Healing and divination were the main stocks in trade of these traditional wise men and women, and both services were performed in highly theatrical and dramatic styles, with costumes, ritual objects, drumming, chanting and sometimes startling displays of possession by other-worldly spirits. On one occasion, I had a chance to

MEANDER TO LABYRINTH

Above: Meander patterns dating back to 20 000 BCE may form the basis for the labyrinth.

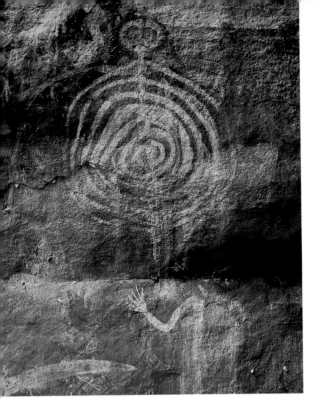

watch a unique ceremony which took place around a series of nine concentric circles drawn roughly on the ground, symbolizing the spheres or heavens (see box on previous page). Was it a prototype for a labyrinth? I do not know, but looking back, it seems to be a good example of how a shaman might have worked with a real labyrinth in the Bronze Age Mediterranean.

One of the most important roles for the ancient labyrinth may have been as a staging ground or an aid for prophecy or divination. The *Pythia* or oracle of Delphi is reported to have spoken her cryptic messages sitting atop a three-legged stool, above a fissure in the earth from which issued trance-inducing fumes. At one stage, she may have prophesied from the middle of a circular, labyrinth-like temple called the tholos, which can still be seen today at Delphi. It was not a true labyrinth, but it gives us an idea, perhaps, of how oracles may have used one to enhance their prophetic powers. At Cumae in Italy, an equally famous oracle gave her poetic predictions in the midst of a vast cave system which has been referred to by more than one writer in antiquity as a 'labyrinth.' Again, this is not the seven-circuit design we see today but a labyrinthine cave, which may have been partly the inspiration for the original design and certainly suggests a strong link between prophets and labyrinths.

Above: Gagadju White Lady, Kakadu National Park, Australia.

Above: Hopi Father Sky and Mother Earth patterns.

Opposite: Native American basket, showing Iitoi in his labyrinth.

Of course a labyrinth is not a bad hat trick for any shaman or prophet. Draw it on the dust of market square or in a clearing within a forest, announce its magical properties and watch the crowd gather. The fascinating pattern draws the eyes of everyone who beholds it. The shaman can use it to tell a story, enact a ritual dance, perform a healing or perhaps to speak an oracle. Labyrinths are excellent devices for inducing mild trance states and producing inspirations.

We can get other clues about some of the ways in which the pathway might have been employed in ancient times from the practices of native people today, such as Australia's Aborigines. Aboriginal storytellers use shapes such as spirals and concentric circles (above) to denote sacred places and beings associated with their 'Dreamings', their creation stories. Frequently they draw these figures on sand or rock or, more recently, on canvas, as a way of relating their stories to younger people. Meanwhile, the Hopi of America's Southwest have two labyrinth shapes which represent Mother Earth and Father Sky,

HOW TO DRAW A SEVEN-CIRCUIT LABYRINTH

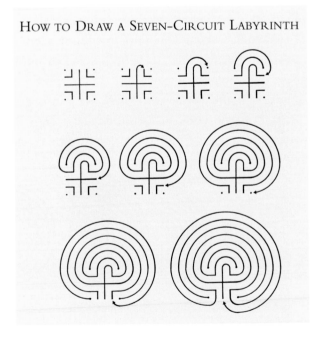

their primary ancestors. For the Tohono O'odham people of Arizona, a different-looking seven-circuit labyrinth is said to represent the path followed by their creator, Iitoi, when he returned to his sacred mountain. Labyrinths seem to be excellent tools for the storyteller.

The labyrinth also seems to have been a symbol for protection against harmful spirits. Labyrinth talismans in the forms of rings and seals appear around the world, presumably for the purpose of warding off the 'evil eye.' On the Indonesian island of Java, the seven-circuit 'Cretan' pattern

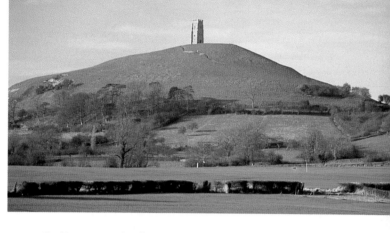

Above: Glastonbury tor, England.

can be found on a series of gold rings dating from the ninth century. In Luzzanas, Sardinia, a seven-circuit path, incised on the wall of a tomb, may have served to trap or warn off potentially harmful spirits (or grave robbers). Labyrinths as hiding places, demon 'traps', protective devices placed at doorways and as barriers against intruders also can be seen in stories from the Middle East to India and Afghanistan. In the Indian saga the *Mahabharata*, a circular labyrinthine formation called a *chakra-vyuha* is used to entrap and kill an opponent. Once he is inside, he cannot escape and no one can come to his aid. In many medieval manuscripts, the ancient city of Jericho is shown as a labyrinth of seven circuits. Today, protective labyrinthine designs, called 'threshold' or *kolam* patterns, are still placed on doorsteps in India to keep unwanted spirits from houses, and labyrinth images have been seen in mosques in Pakistan, possibly for the same purpose.

A final meaning for the labyrinth image of antiquity is as a holy mountain, a place of meeting between humans and gods. Instead of winding down or inwards into a cave or womb of rebirth, the path winds upwards towards the heavens, as seen in the mythical Tower of Babel or the step pyramids of the Maya, Aztec and Inca of Central and South America and

HOLY MOUNTAIN OR SACRED VORTEX?

Which does the labyrinth represent?... a journey upwards to the heavens or down into the earth? People seem to experience it both ways.

in Egyptian pyramids. Many turf labyrinths in Britain have been placed, interestingly I think, on tops of hills—possible ritual centers in Bronze Age and Iron Age times. Indeed, the famous tor at Glastonbury in England's South West is thought by some to be a gigantic terraced labyrinth which leads the walker to the summit where a tower to St Michael can be found, the archangel whose sword of truth pierces the hide of the toughest monsters.

But how did the labyrinth come to be associated with a maze, a prison, the underworld and actual buildings? Let us enter the next level of this mystery … and go to ancient Egypt.

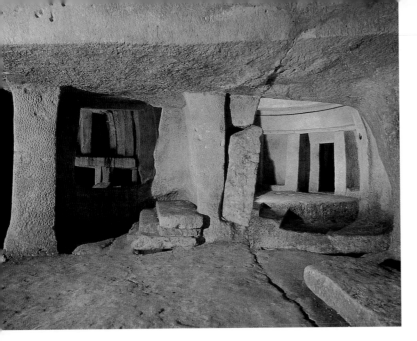

The Labyrinth and the Underworld

Near the shores of a lake in southern Egypt, at Hawara near El Faiyum, lies the now empty site of one of the marvels of the ancient world, a temple built by Pharaoh Amenenhet III in the 19th century BCE. Today nothing much is to be seen of this massive complex, but the fifth century Greek historian Herodotus claimed to have visited it and called it the 'Egyptian labyrinth.' He described it in lyrical, even hyperbolic terms, as superior 'even to the pyramids, which are astounding.' The temple was built in honor of the crocodile god Sebek, a deity closely associated with the realm of the dead and of the Egyptian underworld. Later Roman authors concluded that it was the inspiration for the 'Cretan labyrinth' at Knossos.

Above: The original labyrinth? The cave-like Hypogeum at Malta, c. 3200 BCE, was carved out of solid limestone and once housed the bones of the dead. The word labyrinth may have originally referred to underground chambers such as this one or stone circles such as the famous one at Stonehenge, England (below).

Here we see how mythology and history intersect. From an actual account of a famous building, a connection is made to a fictional one and the link between a labyrinth and a maze—the Egyptian temple is described by the Romans (most of whom never visited it) as exceedingly maze-like—becomes established. As Kern points out, the Greeks of the fifth century, and the later Romans, would have been largely ignorant of any early meanings of the word 'labyrinth.' Associations of the pattern with ancient dances and gods would have been sketchy, to say the least. He debunks the theory that the word 'labyrinth' derives from a name for the palace of Knossos. Instead there is now evidence that it derives from an ancient word for 'stone.' So, 'place of stone/s'?

It is not a bad lead. Immediately one conjures up images of the massive stone circles and semi-below ground temples called cromlechs and dolmens left to us by the Bronze Age megalithic (great stone) builders of Western Europe from 3500 to 1500 BCE. These monuments are mostly scattered from the West Coast of Ireland to Brittany and Malta in the Mediterranean, the most famous being Stonehenge in England. One of the most dramatic yet little-known megalithic creations is on Malta, in an underground labyrinthine temple of several chambers, carved from solid stone, called the Hypogeum. From objects found there, it is thought to have been a place for the ritual worship of a robust-looking goddess as well as a site for prophecy and cultic practices related to death and rebirth.

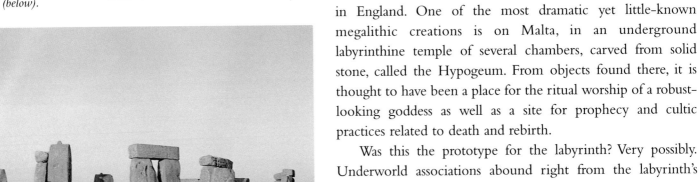

Was this the prototype for the labyrinth? Very possibly. Underworld associations abound right from the labyrinth's earliest mentions and visual references and, as we have noted, the very shape of the seven-circuit path can be construed as a metaphoric 'map' of the cave or womb of rebirth. Herodotus

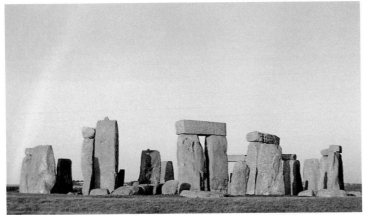

makes it plain that the labyrinth was associated with at least one temple of the dead while the Greeks seemed to be in no doubt that it was a perfect place in which to imprison a fearsome monster. They would have only done so, surely, if the labyrinth was associated in their minds with a notion of the underworld or a tomb.

From the earliest written stories, the underworld was seen a place where gods, goddesses or heroes encountered death-dealing forces and emerged transformed. So it was with Inanna and Dumuzi and Isis/Osiris, then Orpheus, Theseus, Aeneas and later, Christ. Out of death comes new life, sometimes eternal life, the stories assure us. In order to be transformed and to become fully powerful, the god/dess or hero needs to descend and face the fearsome judges and deities of the underworld. Only then can they occupy a place of honor. Significantly, descents into the underworld were invariably associated with the number seven: seven gates, judges, demons etc. And how many circuits are there in the early labyrinth? … Seven.

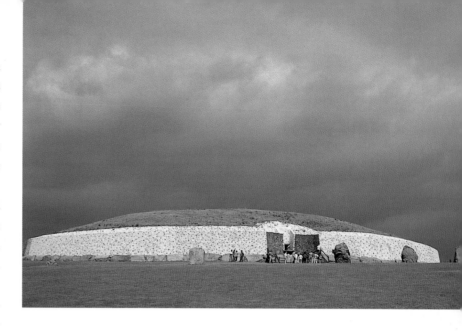

Above: The restored tomb/temple at Newgrange in Ireland, c. 3000 BCE.

Below: Plan of the tholos at Epidauros, Greece, with a three-circuit path in its center.

So it seems very possible that if the labyrinth meant 'place of stone' it could be referring to caves used for ritual and prophecy such as the one at Cumae, or else stone temples of death and rebirth—the Hypogeum of Malta, the magnificent mound-shaped tomb/temple at Newgrange in Ireland, two or three similar large tomb/temples at Locmariaquer in Brittany and of course the Egyptian temple of Sebek, the crocodile-headed god of the underworld—all of which pre-date the appearance of labyrinths. Not understanding this esoteric meaning of the labyrinth, perhaps, the Roman writers of the first century equated it simply with a maze. The fact that Egyptian tomb builders deliberately inserted maze-like false passages and chambers at the entrances to pyramids and other monuments to confuse grave robbers probably added to this idea.

Were there any true labyrinth buildings in the ancient world? So far none has come to light, though one does appear to have a labyrinthine path beneath it: the Tholos of Asclepius at Epidauros in Greece. Constructed in the fourth century BCE, it contains an underground maze-like chamber of three circuits. Asclepius (whose name meant 'all gentle') in mythology was a son of Apollo, the god of oracles, poetry and medicine. His cult was closely associated with the mistletoe, the juice of which was reputed to have magical healing/regenerative powers. Moreover, he was said to take the form of a snake, which the Greeks associated with, among other things, oracular divination.

Here again is an underworld reference for our labyrinth, only this time it is also associated with the serpent of healing and divination—strong evidence that in spite of misinterpretations about form, the labyrinth's purpose as a tool for underworld journeys of initiation, healing and prophecy was well understood in the ancient world.

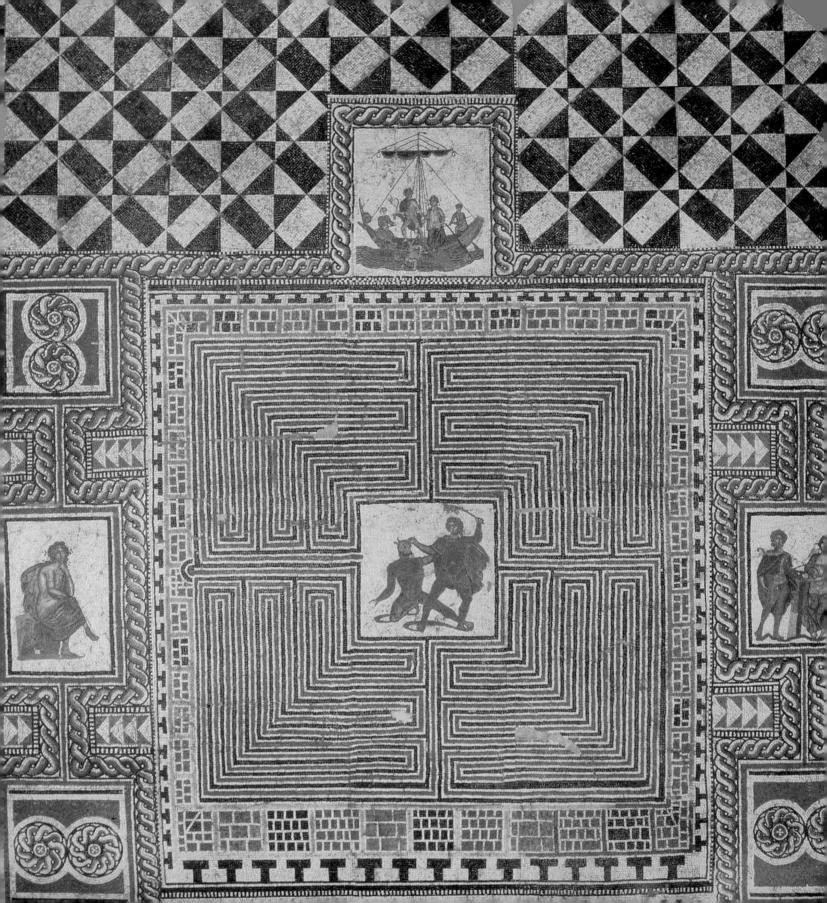

4. ROMAN LABYRINTHS

From the first century BCE to its collapse in the fifth century, the Roman world fell under the spell of the labyrinth. Indeed, we can say it was the Roman obsession with the 'Cretan maze' and with the story of Theseus which was largely responsible for its spread into Western Europe and for the first 'maze craze' in history.

Spurred on by tales of heroic adventures and dark, bull-headed monsters, the Romans created labyrinths in mosaic patterns on the floors and walls of many of their villas and country houses, as far afield as Germany, Cyprus, North Africa and Britain. More than 50 of these survive today, some in just fragments, others, such as the beautiful example from Salzburg, Austria (left) almost fully intact. Few are large enough to be walked. They were intended more as designs, motifs, curiosities perhaps—elegant, erudite complements to an educated man's household. Given that many of them occur near entrances and doorways, we can assume that they also served a magical, protective function. Romans, after all, were highly superstitious.

Above and below: Roman labyrinth at Fribourg, Switzerland.

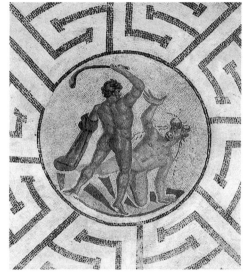

The Roman labyrinth is a hybrid creature. Made up of components of the ancient or 'classical' seven-circuit path, it takes the cross formation and drives it square (and how the Romans loved squares) through the middle of the design, separating it into four quadrants, each of them a mini (sometimes multiple) version of the original seven-circuit pathway. If we were to walk it, we would progress in an orderly, dull but very Roman fashion, from one quadrant to the next, finally arriving at a center where we would often see the figure of Theseus killing the Minotaur. Romans also seemed to like allusions to classical Greek texts.

The four-square design owes a lot to the way they built their cities, according to British writer Nigel Pennick. He points out that the labyrinth is very like a model Roman town, laid out according to the 'Etruscan discipline'—a method of divining a central point or *omphalos* (Greek for navel), then creating the town in four quarters around it. As if to support this theory, many Roman labyrinths feature crenellated walls and towers, reminiscent of a fortified city.

Labyrinths also became prominent in Roman literature in the first century. By this time the Cretan myth was, in the words of a Canadian literary scholar, Penelope Reed Doob, 'the stock in trade of hack poets' as well as of classical writers. While the Greeks had invented the story of Theseus and the Minotaur, they never described the labyrinth very well. That was left to the Romans, who took up the challenge with enthusiasm. Virgil, Ovid, Pliny the Elder and Plutarch all seemed to be especially taken by the story. Why? Perhaps they saw it as an allegory for the dark and violent times Rome had just lived through, including the civil wars surrounding the assassination of Gaius Julius Caesar in 44 BCE. Maybe they saw in the figure of Theseus a model Roman hero, not unlike their new Emperor, Augustus, who had at last brought Rome into a period of economic and

Opposite: Labyrinth mosaic found near Salzburg, Austria.

political stability. There was peace and prosperity in Rome in the early first century. Interest in the arts flourished. Many writers, inspired by the cultural achievements of Greece, turned for inspiration to classical sources.

Pliny, an historian, was concerned with the labyrinth as a work of architecture. He was the one who claimed that the Egyptian temple at Hawara was the inspiration for it. Meanwhile, Ovid, who was more concerned with morals and the 'pathos of love', as one scholar has put it, devoted a large part of his *Metamorphoses* to the Theseus story, describing the labyrinth in dramatic terms: 'Daedalus made those innumerable winding passages and was himself scarce able to find his way back to the place of entry, so deceptive was the enclosure he had built,' he wrote. Virgil, the great poet of the Augustan Age, used a section of his epic *The Aeneid* to describe the Minotaur as a 'mongrel breed … twiformed offspring, record of monstrous love' and the labyrinth as 'that house of toil, a maze inextricable.'

Paths of deception, mongrel offspring, monstrous love … these are the forbidding images of the labyrinth which would carry through into posterity. But there is another side. In Book 5 of his *Aeneid*, Virgil refers to something else associated in Roman minds with a labyrinth: the 'Game of Troy.'

From Augustan times onwards, it was common, at major Roman celebrations and state funerals, for young men of noble birth to perform a ritual ride on horseback called the *lusus troiae* or 'Game of Troy.' We do not know a lot about it except that they rode to a pattern, a circular or winding one, whose paths interwove each other and may have resembled the path of the labyrinth. The drawing on the Tragliatella wine jar (mentioned in Chapter Two), which shows riders emerging from a labyrinth inscribed with the word 'Truia', seems to confirm this connection. Virgil claims that the game originated in Troy, and he and Pliny both provide us with descriptions. Boys aged seven to 17 participated, and there are hints that it was a kind of initiation into society. One imagines something of the nature of the elegant dances performed on horseback in modern times by members of the Spanish Riding School. This leads us to the idea that the 'Game of Troy' was more of a ritual procession or performance than a game.

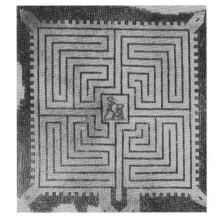

Why Troy? Well, in addition to labyrinths, the Romans were practically obsessed with this fabled ancient city of Asia Minor (Turkey). Virgil's hero, Aeneas, who fled from Troy after its fall, was thought to be a distant founder of Rome and an ancestor of Augustus Caesar. The *Aeneid*, which is about his adventures, was, in Roman terms, a bestseller. Did the game of Troy mimic the path of the labyrinth? We can only guess.

A much greater puzzle lies in the fact that the Roman labyrinth is unicursal (one path). Why not a maze, given that is

Above: Small labyrinth mosaic from Cyprus, first century.

Right: Roman labyrinth with crenellated walls and towers from a villa on the Via Candolini near Cremona, Italy, first century.

how it is portrayed in their literature? It would be easy to create a few false turns and blind alleys but the designers never did. Perhaps they sensed some importance or 'magic' in the original design. Then again, a single-path model simply may have appealed aesthetically. We get a clue and an important hint about the labyrinth's ongoing symbolic appeal from the writer Strabo, who tells us, almost in an offhand way, that the labyrinth is only confusing if you are inside it. If you were to get above or outside it, you would see the way

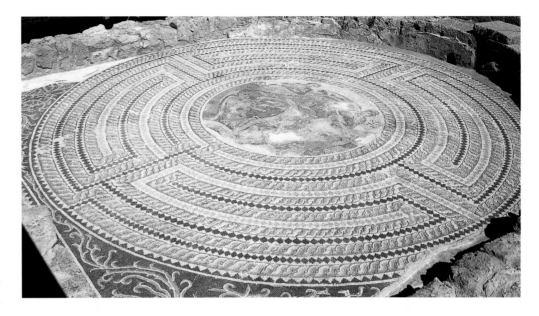

through the maze, the path of Ariadne's string or 'clew.' Is this what the mosaic makers were representing—the way *through* the maze? If so, it makes the Roman labyrinth not a literal representation of the Cretan one but a symbol of guidance and hope … maybe. As usual, there is nothing written to tell us what they intended.

Above: Large mosaic labyrinth with Theseus, Ariadne and the Minotaur in its center. Cyprus, first century.

We get some ideas about their deeper motives, however, from their philosophical preoccupations. Many educated Romans were heavily influenced by Stoic philosophy, especially the writings of Epictetus (55 to around 135 CE) and the emperor, Marcus Aurelius (121–180 CE), both of whom preached what English philosopher Bertrand Russell has called a 'gospel of endurance' in the face of what was, from the third century onwards especially, a time of hardship and poverty for Romans, except the rich and privileged. Epictetus, a Greek former slave who suffered much himself, urged the importance of cultivating 'inner' virtues of peacefulness and a tranquil mind even under appalling conditions. On earth, he said, we are prisoners in our bodies—'I must die but must I die groaning?' he asked. He despised pleasure for its own sake. Freedom from passion and emotional upheaval and the sense that 'your affairs depend on no one' were the secrets of true happiness, he claimed.

Below: Roman tile meanders and star, England.

Russell has implied that in turbulent, politically authoritarian times, the tough go inward, that is thinking people abandon hopes of effecting political change (and the philosophies of social and public virtue that go with them) and instead seek answers and contentment in inward contemplation and the cultivation of what we might call 'inner peace.' Sound familiar? Many will recognize this message as one which is becoming popular again today.

Prosperous but socially troubled periods also breed a proliferation of what are termed 'mystery cults', quasi-religious salvation movements centered on stories and deities of death and resurrection. Rome in the first three centuries had many such cults, especially

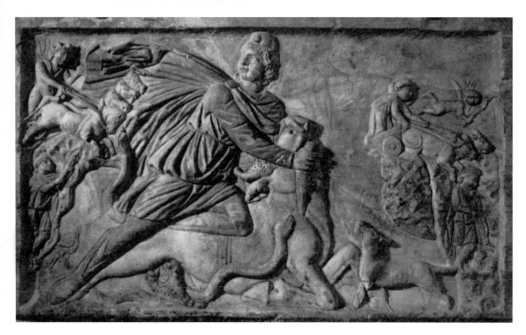

Above: Mithras and the bull. Roman relief, second century.

Right: The goddess Cybele was widely worshipped in Imperial Rome.

Below: Sketch of the Roman labyrinth at Blois, France, showing the stars of the zodiac in its center, third century.

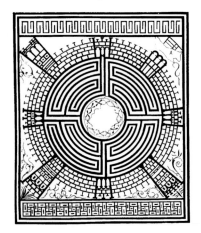

Mithraism (a forerunner and competitor of Christianity) and the religions of Cybele and of Isis, which all featured tales of sacrifice and rebirth. These the follower imitated through spiritual 'cleansing' or animal sacrifices. Christianity itself was seen as one such cult, initially. Then there were the Dionysian and Orphic mysteries, which promised wisdom and escape from mundane reality through either orgiastic rites or deep study of esoteric lore. The appeal of such ideas to disenfranchised people and those whose lives were beset by violence is not hard to understand. They were also much more exciting than the dry, state-sanctioned religions.

The ancient figure of the bull god features in many of these mystery rites, as either a ritual sacrifice (Mithraism) or a partner of a goddess. The worshippers of Cybele practiced a bizarre ritual called the *taurobolium*. Initiates stood under a platform upon which the animal was slaughtered so that they could be 'washed in the blood of the bull', in the belief, perhaps, that the animal's physical power would be transmitted to them as psychic power. Poorer communities sacrificed a ram (the 'blood of the lamb').

Followers of Cybele also practiced self-flagellation and even castration as purification rites.

The worship of Isis was much more genteel. Women were central figures in many mystery cults as priestesses and leaders and, as one writer has pointed out, the worship of powerful female deities like Isis must have been encouraging to them. Many middle class Roman women were drawn to her cult. Isis was seen as a maternal and understanding goddess who could help in times of trouble; as such, she is a direct forerunner of the Virgin Mary (who was often portrayed exactly like Isis, with her child in her lap). Her widespread worship by men as well as women in Rome up to the third century must be seen as an interesting parallel to the period between the 10th and 13th centuries, when both the Mother of God and labyrinths would become popular again. Is there a connection between the two? We cannot say for

sure. All we can say is that labyrinths seem to occur at times when worship of feminine deities is on the rise and when there is a preference for more individualistic, introspective beliefs and practices, especially 'mystery religions' which promise salvation or transcendence through sacrifice, esoteric practices or a spiritual journey. In such times, the labyrinth may be seen as a symbolic path for that journey as well as a tool for initiation into the 'mysteries.'

From the third century onwards, Rome was again troubled by internecine strife and the increasing machinations of its out-of-control army. Assassinations, plots and outbreaks of violence, including attacks by barbarian tribes, became more frequent. Under these circumstances, the labyrinth might have offered Romans comfort or the hope that a redemptive hero, a Theseus, might come to put matters right once again. In the end, of course, we do not know if they viewed their labyrinths as protective devices, symbols for a spiritual journey, representations of a Greek myth or utopian sacred cities. Perhaps they saw them as all of these. Whatever the case, the idea of labyrinths soon spread throughout the Empire, where seven-circuit models later sprang up under the curious names of 'Troy Town', 'Jericho', 'Babylon' and 'Nineveh' suggesting a strong link between labyrinths and holy cities as well as, perhaps, a desire to name them after the labyrinthine and magically protective 'Game of Troy.'

As we have seen, for the Romans, as for earlier people, the labyrinth was a complex symbol. By the end of the fourth century their world was crumbling, however. One sacred city, Troy, was giving up its place to another as the *omphalos*, the symbol of sacred power in the world. That new place would be Jerusalem. At the same time, a new sacrificial god of death and resurrection was arising out of the Middle East to take the place of Theseus and the Minotaur at the center of the labyrinth. He was known by his Greek name, *Christos*, meaning 'anointed.'

In an early Christian church in Algeria, dating to the fourth century, a small Roman-style labyrinth (right) lies on the floor, but in its center, rather than an image of Theseus or the Minotaur, is a word maze: letters arranged in a vertical and horizontal fashion to spell the same thing: Sancta Ecclesia, 'Holy Church.'

The labyrinth had entered the Christian era.

Left: Egyptian Isis was adopted by the Romans as a goddess of nurturing and protection.

Below: First Christian labyrinth—sketch of the fourth century path from the Basilica of Reparata near Orleánsville, Algeria.

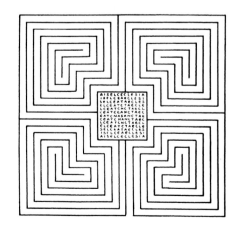

SCANDINAVIAN 'TROY TOWNS'

In Scandinavia there are more old labyrinths than anywhere else in the world. All are made out of stone and some are known by the names 'Troy Town' and 'Jericho', probably as a result of a tradition, from medieval times, of portraying ancient cities, especially Jericho, as seven-circuit labyrinths. They also carry titles which are associated with the words for 'wheel', 'round', 'ring fort' or 'track', or else they are called 'maiden's dance', a connection to both dancing grounds and springtime.

In terms of folklore associated with them, two themes emerge: the first is a recurring story of a maiden or girl who stands in a labyrinth center while a young man dances or runs towards her (hence, 'maiden's dance'); the second relates to the use of labyrinths as protective devices and for magic.

The maiden or goddess in the labyrinth is a familiar story from around the world. A tale from Afghanistan tells of a princess named Shamaili, who lives in the center of a labyrinth-like house on the orders of her father, a king. He has promised her in marriage to any man who can find his way inside, but death for those who fail. Six men die trying to reach the princess, the seventh succeeds (that number again). In Scandinavia too, it seems the game of rescuing or 'capturing' a girl in the center of a labyrinth was a familiar idea. It appeared to be a springtime event, probably associated with fertility rites (see drawing from Sibbo, Finland, above). Magic, too, has been long associated with Scandinavian labyrinths. According to a Swedish researcher, John Kraft, who made an extensive study of Norse folklore and labyrinths in the 1970s, pathways in Scandinavia were often placed near shorelines to 'capture' violent winds before they could do harm to ships. Fishermen sometimes walked them seven times before heading out to sea, to rid themselves of 'trolls', 'gremlins' or other malign spirits which might prevent a good catch. Once caught in the center of the labyrinth, the harmful spirits were believed to be unable to get out. The fishermen would then run to their boats before the spirits could catch up again.

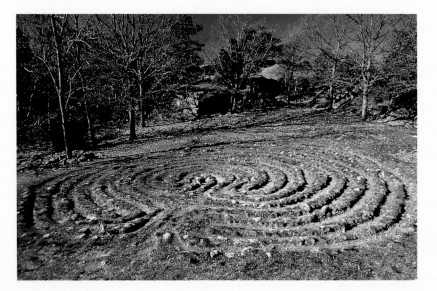

English researcher Nigel Pennick says that the Norse labyrinth also may have been used as a form of binding magic against evil spirits, similar to the way that Celtic knots and other interlace patterns were used by the Irish. A labyrinth in Southern Sweden was said to cure mental illness, and some pathways were considered to be protection against wolves. One labyrinth in Sweden was reported to have been used by a local shaman or 'cunning man', who walked it before undertaking healing or other work. Some Scandinavian labyrinths also lie close to places of execution and burial grounds, indicating a possible association with the underworld and with rites of the dead.

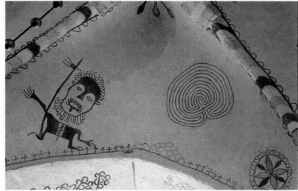

Top: *Coastal labyrinths were designed to ward off harmful spirits and catch strong winds —seaside labyrinth at Gotland, Sweden.*

Left and above: *Frescoes on church ceilings in Turku, Finland and Denmark.*

Opposite: *An 11-circuit labyrinth in Ulmekaar, Sweden.*

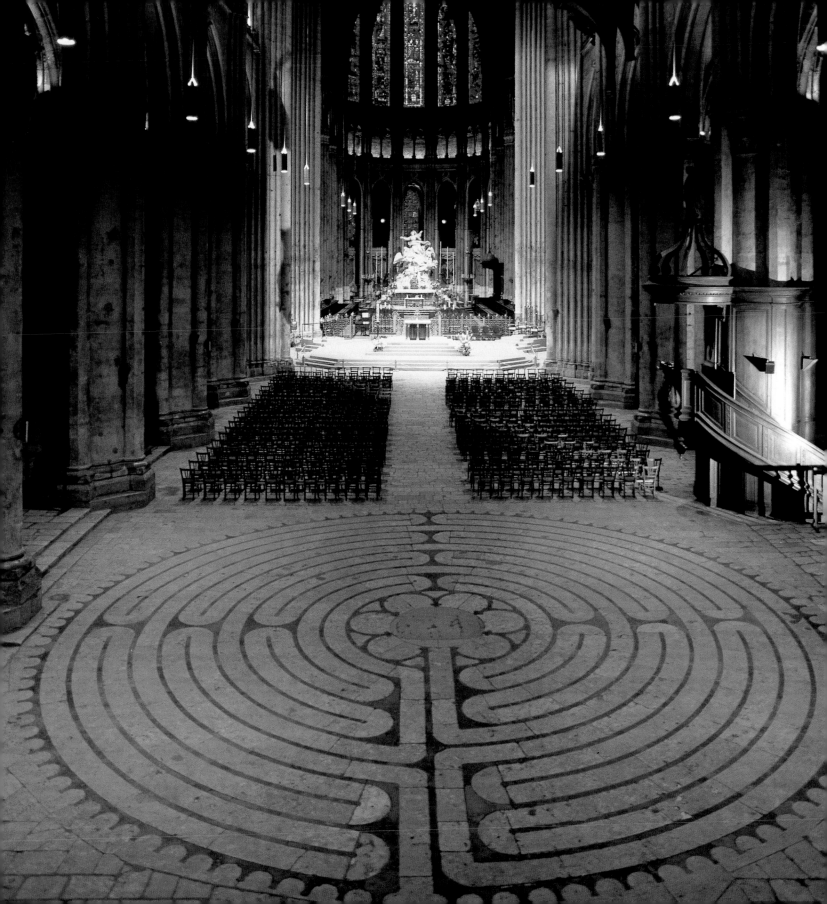

5. THE MEDIEVAL PATH

I shall show you the path which will take you home and I shall give wings to your mind that can carry you aloft … — Boethius, Consolation of Philosophy

This statement, written in 524 by the Italian philosopher Anicius Boethius, under sentence of death, offers us perhaps the defining metaphor both for life and labyrinths in the Middle Ages. The *Consolation of Philosophy* was one of the most popular and widely read books throughout the medieval period. It records a dialogue between Boethius and his fictional female mentor, 'Philosophy.' Within it, many labyrinthine qualities are apparent: life is a path of light and darkness, hope and terror, of confusion but also of guidance, in that what seems confusing is only so because we cannot see the path through the labyrinth. The *Consolation* reflects upon the chaos and sin of the world and at the same time reveals the plan immanent in all creation, unveiled finally as a glorious vision of heavenly platonic spheres with God in the center.

In spite of the difficult circumstances under which it was written (Boethius was executed shortly afterwards), it is a document of shining optimism in a dark world. After the fall of Rome, Western Europe was plunged into chaos and violence yet, despite this, philosophers and writers persisted in offering their readers the promise of transcendence, at least beyond the grave. Their message was clear: If all is rotten in this life, it will be better in the next. Eventually the Dark Ages gave way to a period of relative peace and prosperity, resulting in an outpouring of piety, mysticism, and technological and intellectual discovery between the 12th and 13th centuries, now dubbed by modern scholars as the 'Medieval Renaissance.' This was the period that would see the birth of the Gothic cathedral and the first walking-sized labyrinths in Europe, of which the best surviving example is at Chartres Cathedral, south west of Paris.

From the moment you first see it, Chartres strikes you as an anomaly. Its two great towers loom over you like masonry gone berserk: one Gothic, the other Renaissance, completely different from each other and making no apologies for it. Asymmetry is the essence of this cathedral façade, and just as you have accommodated to that idea, inside are more surprises.

Above: Plan of the labyrinth in Chartres.

Below and opposite: Chartres Cathedral and its 13th century labyrinth.

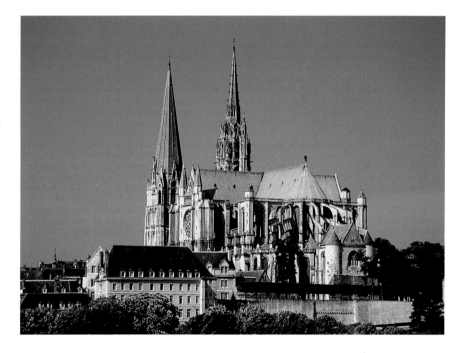

Right: The blue windows over the Western entrance to Chartres.

Above: St Omer pattern, France, 14th century.

Below: Labyrinth at the entrance to Lucca Cathedral, Italy, 12th century.

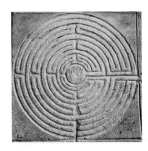

The interior of Chartres is dark, forbiddingly so—the result of all its stained glass, perhaps the best collection of 12th- and 13th-century windows in Europe. As you walk through the doorway, beneath the statues of saints and queens, of carvings showing the signs of the zodiac and the seasons, past the seven liberal arts and Christ and his mother in glory, you are confronted by a deep, all-pervading gloom. Blue-tinted gloom. Turn around and you will have your first encounter with one of the treasures of Western art, the three stained-glass windows above the entrance doors, 12th-century originals, all radiating the vibrant cobalt blue for which Chartres is famous. The middle one portrays Mary, virgin and mother. She is framed at the top in an oval or *vesica piscis*, symbol of the doorway of creation, while down below is the scene of her just after childbirth, offering up her real life infant son, Jesus, to his waiting disciples.

Turn back now and head for the altar. Suddenly before you, on the floor, where you cannot miss it, is the strangest device you may ever see in a church—a pattern that fills the entire nave, made up of a series of concentric circles and a single winding path. Round and around it goes, who knows where? In its center is a six-petal 'flower' not unlike some stained-glass windows. Closer examination reveals the entire mosaic is laid with precision-cut pieces of blue-black marble (the lines) and yellow paving stone (paths). The path draws you in, which it is meant to do. Your feet are upon it before you can think why, and soon you are walking one of the oldest intact pavement labyrinths in the world.

The 42-foot (13 metres) diameter labyrinth at Chartres was laid down, probably around 1200, at the same time as the church was being rebuilt after a fire destroyed the old one in 1194. It may have been the first walking-sized pavement labyrinth to be built (although the one at Sens may have pre-dated it); before it there were just a handful of small, eleven-circuit labyrinths on church walls and floors in Italy, of which the one at Lucca (left) is a good example. After Chartres came some large octagonal labyrinths at Rheims, Arras and Amiens, another round one at Auxerre and an extremely unusual square design (upper left) at a monastery in St Omer. Together these comprised the first walking-sized pavement

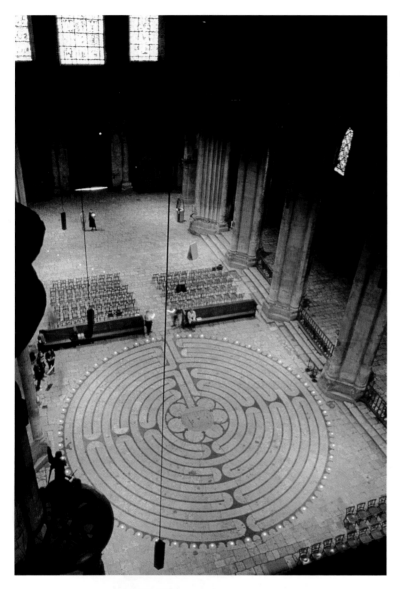

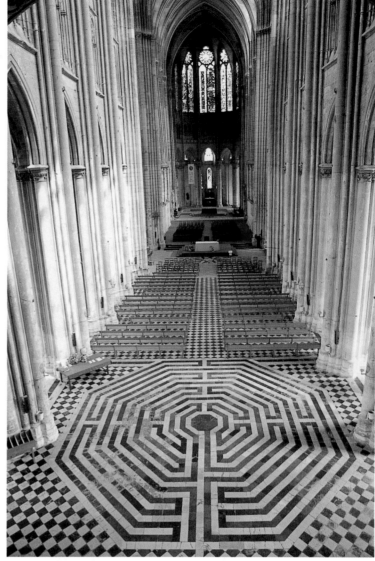

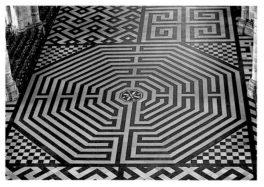

The pavement labyrinths of France—
Top left: Chartres, c. 1200;
Top right: St Quentin, 1495;
Far left: Amiens, 1288;
Left: Rheims, c. 1290,
destroyed 18th century.
Note the Maltese cross in the
octagonal designs.

labyrinths in the world. Later, walkable paths would be built at St Quentin and Bayeux and then, in the 19th century, in Selestat and Guingamp. Outside France there were just four large pavement labyrinths: at Cologne in Germany (since destroyed), Ravenna in Italy and Ely and Itchen Stoke in England. Turf labyrinths in roughly the same pattern as the ones in France, appeared in England from the 13th century onwards.

It is a miracle, of course, that the Chartres labyrinth is still with us, exactly where its meticulous designers laid it eight centuries ago. By rights it should have been torn up with most of the other great pavement labyrinths of France—Rheims, Sens, Auxerre, Arras, Amiens and St Omer—in the 17th to 19th centuries, when labyrinths were no longer 'polite' in church terms and no longer understood. How it survived is uncertain. Perhaps it was just built too well, maybe local superstition protected it, or, maybe the canons of Chartres were less concerned than some of their brethren in other places about its 'pagan' undertones. Whatever the case, it seems the Chartres labyrinth has come down to us more or less in original condition, minus its interior copper plate, upon which was said to be an image of Theseus and the Minotaur or maybe the cathedral's architects; no one is sure. The plate was removed during the Napoleonic wars to be turned into gunmetal.

Chartres Cathedral is a medieval treasure—designed to represent the 'heavenly Jerusalem', the jeweled fabled city of Paradise mentioned in the Bible's Apocrypha. It was built in record time (just 29 years) in the early decades of the 13th century when the 'new' Gothic methods of church building were still being ironed out. It had several architects and building teams who alternated from year to year, each picking up where the others left off, leaving town when the money ran out, coming back in another season. Its interior, then, strikes us as remarkably uniform, a testament to a vision shared.

Chartres is a 'temple to Mary as Queen of Heaven', as Joseph Campbell once put it. The Virgin's image occurs more than 100 times, and the cathedral is dedicated to her bodily assumption into heaven, a controversial doctrine for its time and not officially accepted by the church until last century. In one special window in the South ambulatory, Mary is shown, like Isis before her, enthroned with her infant son on her lap. Above her crowned head hovers a dove, symbol of the Holy Spirit, who bestows on her the fertilizing rays of wisdom; together the trio represents the medieval expression of the conjunction of soul, body and spirit. Chartres also has a black Madonna, famed for centuries for her healing powers and an object of worship by pilgrims who still crowd into the church today. In the back of the cathedral lies the relic which gave the cathedral its fame: a piece of cream silk believed to be part of the Virgin's veil. It, too, is still an object of veneration.

According to John James, an Australian engineer who spent years studying Chartres, the labyrinth's designer was most likely the first architect of the cathedral, but like a true medieval mystery,

Above: La Dame de la Belle Verriere (lady of the beautiful window), Chartres Cathedral.

Right: Chartres Cathedral, the 'Heavenly Jerusalem.'

his name and those of the other builders have all disappeared. We have not a single record and not many clues about how the labyrinth was even used. All we know is that it is the sole surviving large pavement labyrinth of its age and the inspiration, if not the exact model, for many that followed, including those of today.

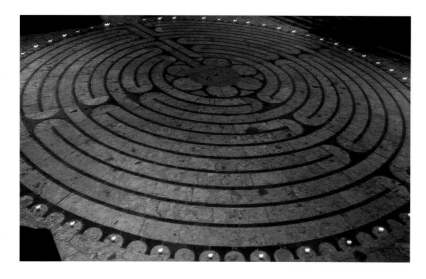

Its design is unique in the medieval world, mainly because of its central 'rose' and the 112 cusps around the outside, sometimes called 'lunations.' A popular theory is that these represent four 28-day phases of the moon, hence 'lunations', but there is no evidence for it. Indeed, there are a total of 114 cusps if you count the two that have been taken out to make the entrance. A more probable explanation, then, is that the designers were copying the crenellations, suggestive of city walls, that surrounded many Roman mosaic labyrinths. This in turn suggests that the labyrinth might have been thought of as a symbol for Jerusalem, the Holy City, continuing the idea of labyrinths as protective devices and symbols of sacred places.

Above: The labyrinth in Chartres measures 42 ft across.

Below left: Chartres' famous black Madonna still draws pilgrims from around the world.

How Was it Used?

There are a few hints about how it might have been used in medieval times. Pilgrims probably walked it or crawled it as an act of penance, we are told (a painful one given the length of the journey, 858 feet or 261.5 metres, and the unforgiving nature of the cathedral floor!). Chartres was an important stop on

all the major medieval pilgrimage routes to Santiago de Compostela, Rome and Jerusalem. Indeed, the labyrinth was sometimes called the *'chemin de Jerusalem'* (road to Jerusalem). Like all church labyrinths, it lies at the Western entrance—the direction of the setting sun, of death and the world—so that it would be the first thing the pilgrim would encounter before he/she entered the sanctuary and the high altar. For this reason, it is thought that all the church labyrinths served a time-honored role as protective devices, ritual gateways to sanctuaries. The visitor may have been meant to leave his/her sins behind in their winding coils.

For the pilgrim, the path might have been seen as a representation of the literal journey he/she was undertaking, often on dangerous unprotected roads

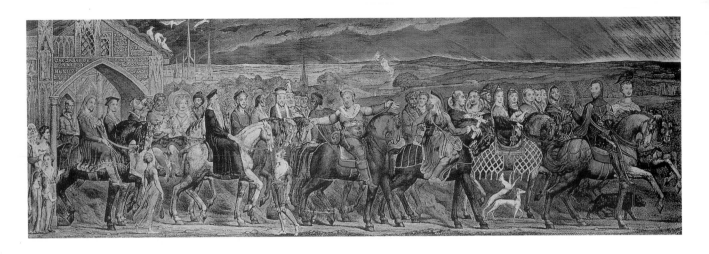

Above: Chaucer's 'Canterbury Pilgrims', engraving by William Blake, 1810.

Right: Earliest manuscript labyrinth, including a Solomon's knot, ninth century, Italy.

Below: Roof boss showing an early medieval labyrinth from St Mary Redcliffe, Bristol, England.

through strange territories towards a shrine or spiritual center. The three parts of the pilgrimage—setting out, arrival and return—were reflected in the three stages of the labyrinth walk. It has been suggested that the labyrinth might have even served as a substitute for a real pilgrimage when conditions prevented travel.

The medieval labyrinth was also closely associated with the Theseus myth. Images of the Greek hero slaying the Minotaur were often placed inside or beside church labyrinths, which might seem odd in a Christian setting. However, there is good evidence that the myth was now being seen in a distinctly Christian light: Theseus had become Christ and the Minotaur was the devil. The labyrinth was construed as the path of the sinful world, winding backwards and forwards but taking the walker inexorably towards the center and redemption in Christ. The guiding thread did not belong to Ariadne this time, but to the Virgin Mary.

The French church labyrinths were also associated with dancing. Records exist of canons and deans performing some sort of ritual dance or game with a ball at Easter time in the labyrinths of Sens and Auxerre up

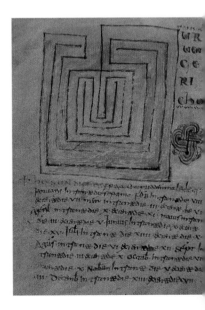

until about 1690, according to Kern. During it, the dean walked or danced the path, in a simple three-step movement, tossing the ball to each of the canons, who, in turn, threw it back to him. The dance may have re-enacted Christ's death and resurrection but we need to remember that a ritual tossing of a ball was also performed all over Europe in springtime to represent the rebirth of the sun. This indicates a possible connection to pre-Christian rites, which may have accounted for why the dance was later banned by the churches.

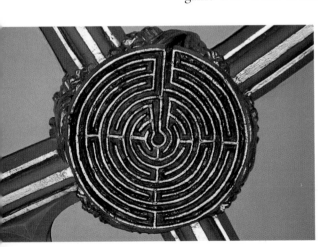

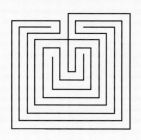

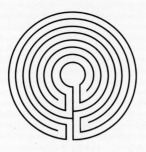

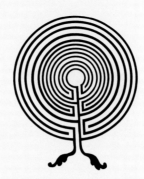

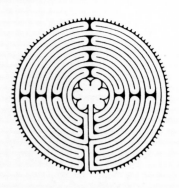

Ancient classical seven-circuit labyrinth, called the 'Jericho' labyrinth, ninth century, Italy.

Concentric seven-circuit labyrinth with enlarged center, ninth century, Aachen, Germany.

Eleven-circuit labyrinth 'Otfrid' model, ninth century, Germany.

Eleven-circuit 'Chartres' labyrinth, 12th–13th centuries, France.

Evolution of the Design

It is obvious that the medieval labyrinth is substantially different from earlier models—the Roman and Cretan paths. To understand how it evolved, we need to go back to the ninth century and turn our attention to medieval manuscripts. After the fall of Rome in the fifth century, the labyrinth all but disappeared from Europe. It resurfaced again in a manuscript from Italy dating from the early ninth century, which shows a square Cretan model very like the one on the clay tablet from Pylos, only here it is called the 'City of Jericho.' It appears above some text describing the 'Dies Aegyptiaci' or the Egyptian unlucky days in Roman tradition, and beside the labyrinth is a curious design called a Solomon's knot, which can be created using the same cross of nine dots from which the labyrinth is formed. A story current in medieval times claimed that the labyrinth was the invention of the biblical wise king, Solomon.

Below: Otfrid's 11-circuit pathway in a manuscript from the ninth century.

Just a few years later the seven-circuit labyrinth again appeared, except that it had been turned into a series of concentric circles with an enlarged middle. This new model appeared in a book written by a monk, Walahfrid Strabo, from the monastery of Reichenau. Then, in 863 a German priest, Otfrid of Weissenburg, wrote a precis of the gospels and illustrated it with the first medieval 11-circuit labyrinth. To create it, he simply copied the seven-circuit model of Strabo and added four more circuits. In the 10th century, a final modification took place—the 11 paths were broken up by a cross laid over the whole design. So was born the famous 'Chartres pattern', although at Chartres itself there were to be important further additions—a rose-shaped center, which we will discuss shortly, and the 112 cusps or 'lunations' around the outside.

Why did Otfrid feel it necessary to create an 11-circuit path? The most obvious answer is that he wanted to have a new 'Christian' labyrinth, separate from the pagan seven-circuit one. Another thought is that he wanted it to symbolize the world as a place of sin, 11 being

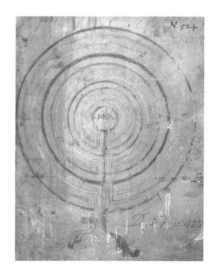

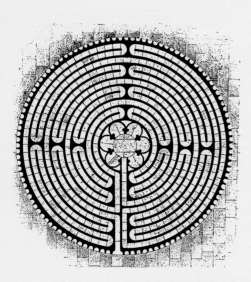

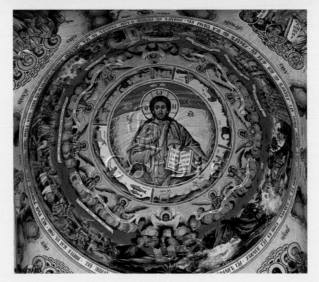

A MAP OF THE COSMOS?

The Chartres labyrinth is very like some medieval maps of the cosmos (above and right), which show a series of spheres with either earth in the center and God on the outermost rim, or the other way around. In the Chartres labyrinth (left), we see a distinct 13th circle inside the rose, which might be meant to symbolize the Divine at the heart of the cosmos. If so, it would have been surrounded—according to the standard medieval map—by a starry sphere (the petals) then the spheres of Saturn (path 11), Jupiter, Mars, Sun, Venus, Mercury, Moon, Fire, Air, Water and finally Earth (path one). In this model, the walker would enter the labyrinth to path five, the Moon, and would exit the center to path seven, Venus. We cannot know if this was what the designers intended, but it represents a possible interpretation.

Above: Versions of the cosmic map— the Chartres labyrinth (left); Christian Orthodox (center); and a 17th-century drawing (right).

the number of sin in Christian thought. However, it might be best if we forget for a moment the number of circuits in the labyrinth and focus instead on how many circles it has, to which the answer is 12, if you count the center (or 13 if you add the additional circle that appears inside the Chartres center). Twelve is a very important number to medieval scholars and artists. It is what you get when you multiply four (the number for the world) by three (the number associated with the Divine), and therefore represents the union of God and nature. It also represents the number of apostles, months of the year and signs of the zodiac. Medieval cathedrals feature a lot of 12-part designs, including the rose windows at Chartres, all of which have 12 'petals.' Indeed the Chartres labyrinth is reputed to be the same size as the rose window which sits above it.

More importantly, though, many medieval maps of the cosmos—based on models from Greek antiquity—show a series of 12 spheres with earth in their center (above right). Moving outwards from earth are the other elements (water, air and fire), then seven 'planets'— Moon, Mercury, Venus, Sun, Mars, Jupiter and Saturn, and finally a *stellatum*, or starry sphere. Beyond these are additional spheres containing the heavenly hosts and God. In some images (above center), the order is reversed: God or Christ is in the center of the cosmos, with the planets and earth on the outside—as in Boethius' vision. Was this reversed cosmic map a model for the 12-circle Christian labyrinth? If it was, then the divine presence would have had to be contained in a 'hidden' 13th realm in its center. In the Chartres and Sens labyrinths we see that

this 13th circle is quite distinct—it lies in the middle of the 'rose.' Of course we have no way of knowing for sure if a cosmic map was intended by the designers, but it seems a reasonable bet, given even a basic understanding of medieval cosmology and number magic. It might also explain why Otfrid increased the number of circuits from seven to 11. English academic, Keith Critchlow, believes the cosmic map certainly influenced medieval labyrinth design, although he posits that the 12 circles symbolized the signs of the zodiac. Either way, it does not matter. What is important for us to think about is whether or not the labyrinth was intended to be more than just a simple metaphoric 'path of sin' and salvation, as has been suggested by other commentators.

The Cross and the Rose

Let us take a closer look now at the cross in the labyrinth. To begin with, it is not a standard Christian one but an equal-armed cross, which, as we know, originates in antiquity and is present even in the seven-circuit and four-square pagan labyrinths, as well as in much earlier designs, such as the swastika or 'cross of the sun.' Indeed, the Maltese cross, which can be seen in the 13th-century octagonal labyrinth designs, originates in Syria. It and many other symbols were thought to have been introduced into Western Europe by the Arabs in Spain and later via returning Crusaders, especially the Knights Templar.

Above: A calendar wheel from the a 16th-century Spanish manuscript.

Left: A Chartres-style rose center.

Below: Six-part rose window with a 'Seal of Solomon' from the cathedral of Notre Dame, Paris, France.

From an examination of medieval manuscripts (upper right), we can see that a cross within a circle was a favorite Christian symbol too. According to scholars, it stood for the cross of the world or 'world tree', fused with the circular cosmos, the realm of the Divine. In its center was often another circle, which, in educated medieval minds, often stood for the so called 'fifth element', which the Greeks had called 'ether' and which in Western thinking translated as the *materia prima* (primary material), of which all of nature was thought to be composed (it is interesting that currently physicists around the world are still searching for a 'primary' particle of matter, only now it is called a 'Higgs Boson'). It should be obvious how this circular cross forms the basis for the geometry of the labyrinth.

Let us now consider the chief innovation of the Chartres path—its six-petalled 'rose.' What were the designers intending here? On a simple level, we can see that it is similar to stained-glass rose windows, which were common to many medieval cathedrals. The rose is also thought to be a representation of the Virgin Mary, the 'rose of creation' and of life itself. The number six, however, hints again at deeper, esoteric meanings. Six was associated with the 'seal of Solomon', usually portrayed as a six-pointed star, a potent symbol in medieval

minds, representing the union of spirit and matter, fire and water. In alchemical treatises, which reached the West early in the 12th century, such a union was symbolized by the marriage of sun and moon, sulfur and quicksilver, of the active masculine and reflective feminine principles. The joining of opposites was considered essential for the production of the 'philosopher's stone' or the 'elixir', which was purported to be able to transform ordinary matter into gold—a metaphor for spiritual transformation later (by the Renaissance certainly) taken as a literal recipe for turning lead into gold. Some alchemical manuscripts show this process as a labyrinth-like holy mountain called the *'mons philosophorum'*, a symbol for the long and convoluted process by which the transformation was meant to take place.

According to a 13th-century Arab philosopher, Ibn Arabi, 'Gold corresponds to the sound and original condition of the soul which freely and without distortion reflects Divine Spirit in its essence, whereas lead corresponds to its 'sick' distorted and 'dead' condition … the true essence of lead is gold.' In order to free the soul, he says, its primary essence or materia (gold) must be dissolved out of it through fire— the fire of spiritual transformation. A modern Swiss scholar, Titus Burckhardt, has elucidated what he sees as six phases in the alchemical process, corresponding to six of the medieval 'planets' (Saturn, Jupiter, Moon, Venus, Mars and Sun), guided by the presence of the Hermes-like seventh planet, Mercury. Such processes were often portrayed as taking part in lobes or spheres (below right). Did the Chartres labyrinth's 'rose', to some minds at least, represent these alchemical stages?

Above: The mons philosophorum *(Philosophers' Mount), an alchemical symbol of regeneration, engraving, 1604.*

Right: The stages of the alchemical process shown as spheres, by Lubeck Ripley Scroll, 1589. Note the man and woman entwined on the tree — a symbol of the union of opposites.

The idea of a quest for a magical object, a 'philosopher's stone', which could effect spiritual realization or transformation was very attractive to medieval minds (hence the popularity of stories about knights going in search of a 'Holy Grail', with which the philosopher's stone has a lot in common). It is especially significant that alchemists apparently saw the transforming quest as a descent into a dark underground, reminiscent of the underworld of earlier mythologies. They even had a magical saying: 'Visit the interior of the Earth; there, through purification, you will find the hidden stone.' Did some scholars connect this idea to the labyrinth? Did they see it as a place of transformation and rebirth?

Chartres was a center of considerable scholarship in the 12th century. Its cathedral school was the rival of ones at Cluny and Paris and attracted some of the best minds of the century, including John of Salisbury. It is likely that the scholars of Chartres would have been familiar with the writings of Aristotle and the alchemists by the time the labyrinth was being made. Again, whether or not such ideas directly influenced the design of their unique labyrinth we cannot say for sure, but its geometry certainly points to Platonic, alchemical and Aristotelian influences. If it was not a deliberate intention but merely a combination of

designs for other reasons, it is likely that the pattern nevertheless had a profound impact, particularly among monks and scholars, who would have at once recognized its symbols. Apart from the obvious linking of the cross of Christ with the cosmos and of divine spirit fused with matter, there is the possibility that educated medieval minds might also have seen in the labyrinth a device of unique transforming power. This is particularly likely when we consider the religious and cultural climate which gave birth to it.

The Cultural Background

As in late Roman times, the 12th and 13th centuries in Europe saw a flourishing of mystical ideas, public repentance and purification rites. This was a prosperous era for many, but life was also hard and unpredictable, and the desire for escape from poverty and disease through miraculous interventions was rife. Magical devices such as talismans and stones that offered protection or relief from suffering were extremely popular. The hopes of many lay in their devotion to the Virgin Mary, the ever youthful and beautiful mother of Christ—a defacto goddess. The cult of the Virgin, as it is sometimes called, was led by the 12th-century French mystic and ascetic, Bernard of Clairvaux, who had a particular devotion to her and who preached a gospel of hard work and sacrifice. The Virgin was seen as the chief intercessor for sinners and as the help of human souls. In her name, vast sums of money were raised for cathedral building, and at Chartres people from all walks of life came together in extraordinary displays of public devotion to haul heavy carts laden with stones for the work. The 'miracle of the carts', as it came to be known, served a penitential purpose, the work being undertaken for remission of sins—another feature reminiscent of the mystery cults of Roman times.

Above: Alchemical mystery—the soul in transformation emerges from a river to be greeted by an angel in gold who hands him a red cloak, symbolizing the next stage of his journey.

Left: Knights of the Round Table and the Holy Grail, Gaultier Map, 1470, by French School, Livre de Messire Lancelot du Lac (15th century).

The 12th century was also an era of romantic ideals and of courtly love, when troubadours went from town to town singing the praises of noble ladies and heroic knights and telling stories of a sacred cup of magical, mystical power called the 'grail', in search of which men undertook dangerous, labyrinthine journeys. In such a climate, stories of miracles and transformations abounded. Romantic and allegorical tales such as 'Tristan and Isolde', 'The Romance of the Rose' and the Arthurian and grail romances all idealized love or sacrifice as transforming forces for salvation.

*Above: Life as a
labyrinthine journey.
'Plan of the Road from
the City of Destruction
to the Celestial City',
19th century engraving
for an edition of
'Pilgrim's Progress.'*

*Below: Pilgrim on the
path—tile design
showing the plan of the
turf labyrinth at Saffron
Walden in Essex, U.K.*

Opposed to the mystical, romantic movement was a much more sober but equally vibrant scholarly one. This was an age of new and radical ideas, among them the notions that human reason and logical argument were valid paths to comprehending God. Such ideas were put forward by the French monk Peter Abelard, among others, who was condemned twice by the church and came to be known as one of 'four labyrinths of heresy' in France. Abelard, like many learned men in his time, was influenced by Aristotle, whose writings had just been translated from Greek, and by other ideas emanating from the East. The Crusaders, especially the Knights Templar, who had spent long periods in the Eastern Mediterranean, may have brought back esoteric knowledge from the schools they encountered there. From all this, it becomes clear that Chartres, with its liberal, scholarly population, was a perfect environment in which new ideas could be tried, one of which might have led to a labyrinth being laid in the new cathedral.

Did the scholars of Chartres see in the labyrinth a path of transforming power, a place where a Christian could encounter God and not only be cleansed of sin but permanently changed? Was it a path upon which ordinary souls might be given the spiritual means for dealing with a chaotic and violent world? Did some even see it as a meeting place between heaven and earth, where the soul could ascend through the spheres and reach the top of the holy mountain, the 'philosopher's mount'? Unfortunately we will never know. All we have to go by is the elegant design they left us and, thanks to the perseverance of the labyrinth idea, its effect on us today, which might be, after all, the best and only way we can judge its meaning. Before we go to modern times, however, let us look at what happened to the labyrinth after the 13th century.

Post-Medieval Labyrinths

The early 14th century saw a rapid decline in the economic prosperity which had fueled church and labyrinth building during the 13th century in France. Population growth resulted in heightened competition for food, and there were famines in the early 14th century, as well as outbreaks of disease, leading to the disastrous eruption of bubonic plague in 1348, which spread from the Southern Mediterranean throughout all of Europe and came to be known as the Black Death. It is estimated that it wiped out between a third and two-thirds of Europe's population. Warfare broke out again between England and France in 1339 and continued on and off for the next hundred years. The 14th century also became known for its ferocious persecutions under the papal-instituted Office of the Inquisition, which had been commissioned in 1229 in response to the increasing number of heretical sects within

the church. Prominent among the inquisitors' targets were Jews, women and priests or monks who preached poverty as a virtue and who criticized the church for its corruption and excesses. Many were tortured and burned alive.

In this repressive and violent climate it is no surprise that the building of pavement labyrinths in French churches virtually ceased, although garden labyrinths, made out of hedges and shrubs, appeared from the 14th century onwards. Most of these were created in the grounds of French stately houses. In England and Germany, many turf labyrinths were also built at this time. We know this because of references to them by Chaucer (1340–1400) and later, Shakespeare. Chaucer reminds us of two names for medieval labyrinths: 'laborintus' (from the Latin words *labor* and *intus* meaning 'working into' or an 'inner work') and 'Domus Dedaly' or the house of Daedalus. It is likely that the English labyrinths were inspired by the French medieval church models, given that their designs are very similar. Many occur near monasteries, which hints at religious usage; the presence of seven- and nine-circuit turf labyrinths in other places also indicates the survival of an earlier pagan turf labyrinth tradition.

Throughout the 14th century, the labyrinth was again associated with maze-like inextricability, confusion and impenetrable fortresses, as well as with secrecy, especially military secrets and those of love. It was also used to illustrate classical Roman works and as a symbol for the walled city of Jericho.

Between the 16th and 18th centuries the first hedge maze 'craze' took place in Europe. Elaborate maze gardens were placed within the grounds of palaces, chateaux, villas, parks and public buildings from Spain to Italy, France to Northern Europe. The earliest hedge models were single pathways that looked like the labyrinths in Chartres and other cathedrals. Instead of pilgrimage, however, they were associated with romance and the treacherous path of erotic entanglement. For this reason Kern has called them 'labyrinths of love.' Many paintings of this period show them as metaphors for erotic adventure, their twists and turns

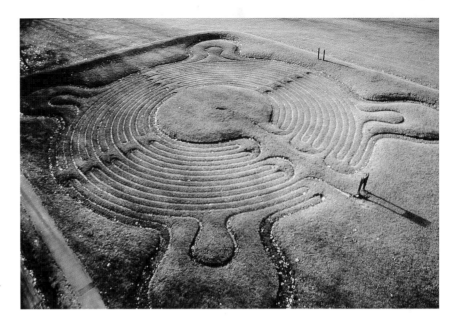

Above: The 17th-century turf labyrinth at Saffron Walden, England, has four extended bastions and seems to follow the pattern originally laid down at Rheims Cathedral, France, in the 13th century.

Left: A labyrinth of love? Hedge mazes also brought back the worship of nature—'The Old Faun' by Santiago Rusinol i Prats, Spanish painting, 20th century.

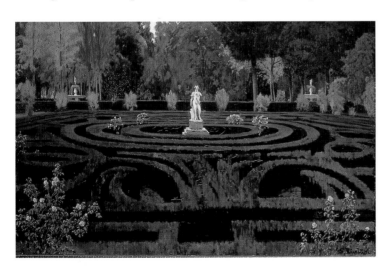

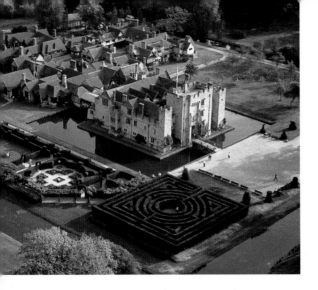

Above: The 20th-century hedge maze at Hever Castle, Kent, U.K.

Right: Plan for the hedge maze at Villa Pisani, Italy.

Below: Design for a garden maze, Dutch drawing, 16th century.

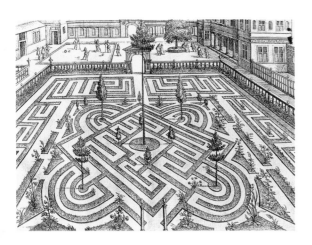

standing for deception and the changing fortunes of love. Maypoles or trees often featured in their centers, and it appears that in France the labyrinths were used as part of May time dances and customs such as the crowning of the May King or Queen—harking back to pagan rites. The association of labyrinths with Eros carried through into literature, too, with certain French writers from the 16th century onwards referring to female genitalia as the 'precious labyrinth of voluptuousness' and 'that beautiful maze.'

With the coming of puzzle mazes, single-path labyrinths began to fade from view. The new multicursal models, surrounded by high hedges, were intended for the walker to get lost in, mostly for the amusement of bored aristocrats. French, English, Dutch and Italian landscape architects and gardeners vied with each other to produce ever more intricate maze designs. Pattern books printed during this period attest to their variety and ingenuity. The mazes often covered many acres of ground

and incorporated trees, fountains, statues and enclosed nooks for rest and conversation (or romantic dalliance). Many were designed around mythical or symbolic themes. At Versailles, near Paris, a large hedge maze, completed for Louis XIV in 1674, featured paths through dense vegetation as well as numerous statues and fountains, recalling the fables of Aesop. At about the same time, an

ingenious hedge maze was designed for Hampton Court Palace in London—this, luckily, remains in restored form. By the 17th century, except for turf models, unicursal labyrinths had all but disappeared.

Within literature, the labyrinth's reputation suffered badly in the 14th century, as writer after writer used it as a metaphor for depravity. The mythical Minotaur was seen as a symbol for the dangerous human heart and also as a product of carnality and lust 'which in women is insatiable', as many a medieval cleric was inclined to put it. As Penelope Reed Doob has revealed in *The Idea of the Labyrinth*, French writers, in particular, saw in the labyrinth a symbol for corruption. Petrarch described the papal city of Avignon, which he saw as hopelessly evil, as the 'third Babylon and the fifth labyrinth.' Then, in the closing decades of the 14th century came a seething diatribe against women, *Il Corbaccio*, by the Italian writer Boccaccio, which equated the labyrinth with the 'pigsty of Venus' and the 'court of love.' By its end the hero has been cured of his lustful obsessions and declares that henceforth he will tread only the 'path of light.' The story tells us everything we need to know of late medieval ideas about labyrinths, sex and women. By far the most important labyrinthine work of literature in this period, however, is Dante's *Divine Comedy*, first published in the early years of the 15th century. This epic, three-part journey of the author

through the imagined worlds of hell (*Inferno*), purgatory (*Purgatorio*) and heaven (*Paradiso*) is primarily concerned with the conversion of the Christian soul from confusion to enlightenment. According to Doob, it employs the metaphor of the labyrinth in its description of the landscapes of each realm, seen alternately as multi and unicursal paths, as well as in its description of the pilgrim's spiritual journey through each one. Dante's guide, Beatrice, can be seen as a kind of Ariadne, who provides him with the magic thread to make his way through each realm. Doob also shows how the *Comedy* is a complex elaboration of the original Cretan myth, transformed into a story of Christian salvation. As such, it might have provided an important source of inspiration to walkers of labyrinths during this period.

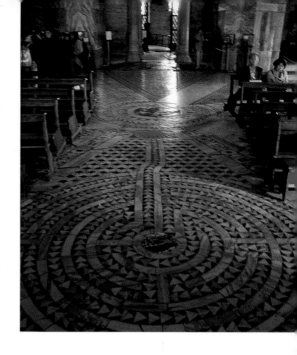

Medieval texts set the understanding of the labyrinth as a path of fate or fortune and earthly life by Renaissance times. In 1631 John Amos Comenius published *The Labyrinth of the World and the Paradise of the Heart*, in which he equated the world with a labyrinth and illustrated it as a fortified city of many twisting streets. This was in keeping with other books of the period, which portrayed the Christian pilgrim adrift in a labyrinth of life with only the guiding thread of God's word, offered by an angel, to show him the way back out. The labyrinth path, like the cosmic spheres of Boethius' vision, was intended to be a revelation of divine order and of God's grace at work in the world. As we shall soon see, this idea of guidance and 'enlightenment' would become crucial to the path's appeal in later times.

Above: 16th-century labyrinth inside San Vitale, Ravenna, Italy.

Left: The late 19th-century labyrinth at Ely Cathedral, England, is a unique design based on the Rheims/Saffron Walden patterns, with extended bastions.

But what of the not-so-humble hedge maze? What happened to it after the 17th century? It became a symbol for nature—an orderly tamed version of her, anyway—carefully sculpted by human reason, of course, which by the 18th century had assumed god-like qualities. During the period which we now call the Enlightenment, Europe was to see the 'triumph of reason over superstition.' It was during this time that the emerging gospel of science would be loudly proclaimed, and even the hedge maze would eventually fall into disfavor as a 'silly pastime.' Most of the hedges were torn out in the 18th century,

along with many pavement labyrinths inside churches. Except for a few turf mazes, the ancient path all but disappeared, only to reappear again, briefly, in the late 19th century, when romantic yearnings and a renewed burst of nature mysticism would again usher in a phase of labyrinth building inside churches in Britain and France. Hedge mazes, too, made a modest return in this period, but neither movement was anything like the one that would take place 100 years later, in the final decades of the 20th century. It is time now to turn our attention to the labyrinth from that period onwards, and especially in its latest incarnation, here at the dawn of the 21st century.

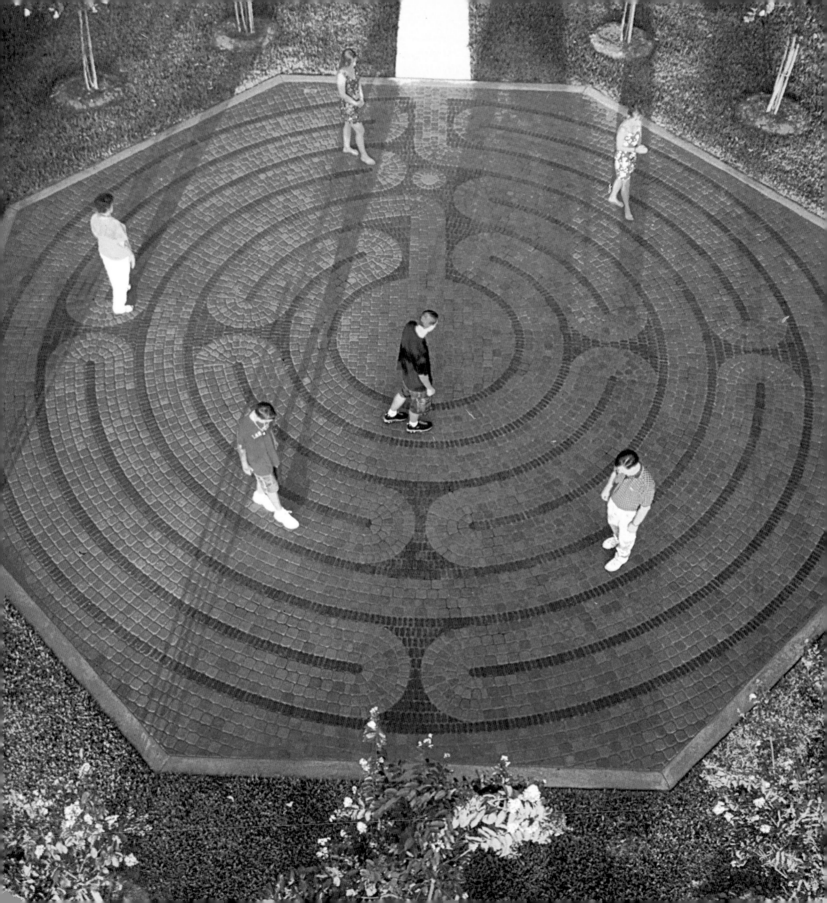

6. THE MODERN REVIVAL

I wish to arrive and walk with grace upon my own path. I wish this for all beings and for Mother Earth herself. — 'wish for the millennium', Byron Bay, Australia, December 31, 1999

On New Year's Eve, 1999, as cities all over the world prepared to celebrate the birth of a new millennium and a new century, small but dedicated groups of people in several countries gathered in churches and parks, on beaches and in back yards to welcome the year 2000 in their own way—by walking a labyrinth.

Like pendulums, their bodies moved backwards and forwards across the semicircular pathways of the ancient design, quietly marking the countdown into the unknown realm of the future. Some did their walks inside cathedrals accompanied by music and prayers, others were on hilltops with drums and gongs, some people walked in silence, others danced and sang. As midnight approached many gathered in the center of their labyrinths. There they said goodbye to the 20th century and spoke of their dreams for the future. In one such 'millennium walk' in a small seaside town on the Australian east coast, participants were asked to write down their wishes for the new era. Again and again, the same word occurred: 'peace'… peace in the home and at work, peace in the wide and busy world, peace for their children, for Kosovo and in the Middle East.

Above: Grace Cathedral, New Year's Eve, San Francisco, U.S.A.

Opposite: Labyrinth in the Santa Rosa™ style, designed by Lea Goode Harris, built by Marty Kermeen in Shreveport, Louisiana, U.S.A.

Since the 1970s, throughout the developed world, the labyrinth has been making its biggest come-back of all time. In previous eras of its emergence, actual walking-size models were few and far between. Today it would be no exaggeration to say that most major cities in the U.S.A., Canada, Britain, Australia, New Zealand as well as certain parts of Europe and Russia have at least one labyrinth, and many have several or even dozens. Labyrinths now come in all shapes and sizes, and from three to eleven circuits; there are paths made in a range of geometric shapes, as well as ones mown into maize fields and grass. Labyrinths are also being created out of plastic tubing, packing tape, surveyor's flags, soft drink cans and chalk; some are designed with water and others in light (see pictures page 71).

A pathway may take months to make or just minutes. In Ottawa, Canada, a nurse, Ruth Richardson, can put down a seven-circuit path in hockey tape in ten minutes. A Chartres model takes her about an hour and consumes 18 rolls of tape. She likes to create the labyrinths quickly so that some of her patients can come and walk them, she says.

Around the world, labyrinths are appearing in a range of contexts and in forms unimagined in past eras. Indeed, if the medieval designers of the 11-circuit path could see the ways in which their invention is

being used today, they might be shocked, for the so-called 'church labyrinth' has left the church and is now appearing all over the secular world: in hospitals, prisons, public gardens and squares, in wilderness parks and even on beaches. Labyrinth-like forms have entered into architecture and are featured in designs for everything from jewelry to advertising. Like the emergence of a butterfly, the labyrinth seems to have metamorphosed into something approaching a modern art form. Meanwhile, its more playful cousin, the puzzle maze, is reaching new heights in design and construction methods too, enchanting a whole new generation of maze walkers. Before we look in more depth at the social factors behind the current revival and see how labyrinths are being used today, let us go back and briefly survey the history of the current movement. The genesis for it appears to have come mainly from England and Germany.

Above: Guggenheim Museum, New York, architect Frank Lloyd Wright's labyrinthine masterpiece.

Below: 1956 English advertisement for coach trips to Hampton Court, with a teacher and class in a maze.

'Father, who made mazes?'

That question, posed on an English beach in the 1920s by William Matthews' young daughter, Zeta, launched the first comprehensive 20th century history of labyrinths. Matthews, a public servant from Ruislip, Middlesex later admitted that his efforts to answer her question 'had not led to complete success.' Nevertheless in 1922 he laid down, complete with illustrations and photographs, the founding study of the labyrinth: *Mazes and Labyrinths: A General Account of Their History and Developments.* The book was reprinted in 1970, perhaps inspired by the 'psychedelic revolution' and a revival of interest in ancient symbols. Immediately it sparked a wave of new publications including Janet Bord's *Mazes and Labyrinths of the World* (1976) and Geoffrey Ashe's *The Glastonbury Tor Maze* (1979); then in 1980 came *Caerdroia, The Journal of Mazes and Labyrinths*, established by Jeff and Deb Saward, which became a forum for labyrinth researchers from Europe and the U.S.A., including Sweden's John Kraft and Bo Stjernström and American and English practitioners of geomancy (divination and study of energy patterns in the earth). Jeff Saward has gone on to conduct extensive research into labyrinths, photographing and cataloging examples from Southern Europe to the Baltic Sea. Today he is recognized as a world expert. Another English researcher, Nigel Pennick, published, from the 1970s onwards, several studies of labyrinths and mazes and also built seven-circuit models in his native England, and Ireland, Austria and the U.S.A., where he laid out what he claimed was the 'first permanent stone labyrinth in North America' at the Ojai Foundation near Los Angeles.

Meanwhile, a handful of maze designers in England were experimenting with new forms. Greg Bright, Randoll Coate, Graham Burgess and Adrian Fisher all began constructing mazes and labyrinths in the 1980s. An English sculptor, Michael Ayrton, who identified himself with the mythical maze-maker Daedalus, following a mystical experience he had at Cumae, Italy (Daedalus' supposed landing place after he flew out of the labyrinth on Crete), went on to build the first modern sculptural maze in the U.S.A. at the home of a New York financier in Arkville, in the Catskill Mountains. Constructed from 210,000 bricks and measuring 200 feet (61 metres) wide, it featured, in its center, Ayrton's extraordinary sculptures of the Minotaur as well as of Icarus and Daedalus.

Above: Jewelry from Arizona showing the 'Man in the Maze.'

Below: Dancing in a labyrinth made of wood blocks in Sweden.

The German side of this story begins, according to author Helmut Jaskolski, as early as the late 1950s, with a series of books about the maze as a literary motif. This was followed by an exhibition of labyrinth art in Berlin in 1966. Then, from the early 1970s onwards, German art historian and lawyer Hermann Kern began amassing information and illustrations of labyrinths. This culminated in a massive exhibition in Milan in 1981. According to Jeff Saward, the exhibition attracted 120,000 visitors and its 434-page catalogue sold 3200 copies, indicating the enormous interest in the subject among Europeans. The following year, 1982, Kern published his masterwork, *Labyrinthe: Erscheinungsformen und Deutungen; 5000 Jahre Gegenwart eines Urbilds* which ran to nearly 500 pages and featured 666 illustrations (it has recently been released in a 360-page English edition, *Through the Labyrinth*, by Prestel.) It remains the definitive history of the labyrinth to date. The 1980s saw the labyrinth become the favored metaphor for many German writers.

In 1983 an Italian academic, Umberto Eco, published, to great acclaim, his labyrinthine novel, *The Name of the Rose*, which centers on a labyrinth (actually a maze) inside a medieval monastic library and culminates with a dour statement by its central character William: 'I should have known well that there is no order in the universe.' Another writer, Jorge Luis Borges, from Argentina, likewise utilizes the labyrinth as a metaphor for chaos and for human knowledge, and Czech novelist Franz Kafka uses its imagery to describe large cities.

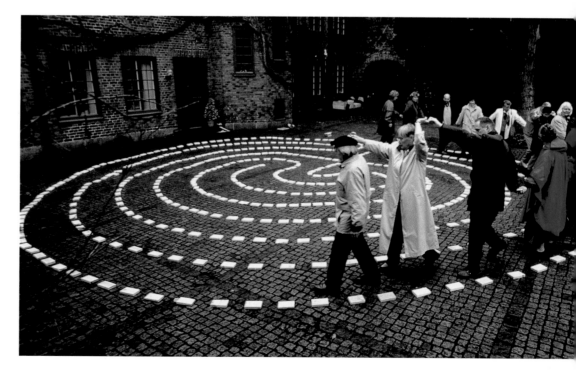

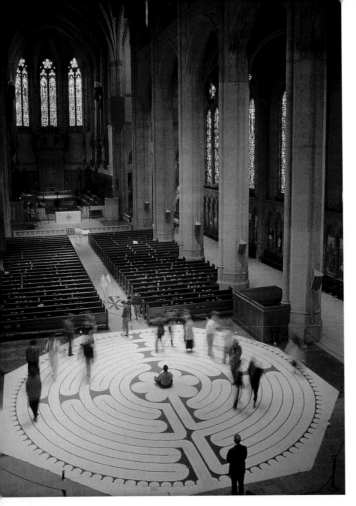

The American Revival

The labyrinth movement in America emerged late in this story—from the mid-1980s onwards—but once it happened, it took off rapidly, and now there exist across the United States more labyrinths than anywhere else in the world. The overall character of this movement is more spiritually oriented than in Britain or Europe. St Louis labyrinth-maker and teacher Robert Ferré sees two paths for the American revival: one centered on churches, another based on the work of American dowsers.

The church folk embraced the labyrinth after author and therapist Jean Houston began using a Chartres-style pathway, which she called a 'dromenon', in her personal growth workshops from the mid-1980s onwards. It was at one of these that a San Francisco Episcopal priest, the Rev. Lauren Artress, encountered the path and, as she freely admits, became preoccupied with it. After a visit to Chartres where she removed the chairs from the labyrinth and walked it, she came home to Grace Cathedral in San Francisco and proceeded to try to create a replica of it on canvas. After much trial and error she succeeded, and the first labyrinth walks were instituted at the cathedral. Money was then raised via donations and fees to have a permanent tapestry model installed in 1996 and then a large terrazzo model outside. It is estimated that up to a million people have since walked the labyrinths at Grace Cathedral. This widespread interest has led to a flurry of canvas and

Above: Labyrinth in Grace Cathedral, San Francisco.

Right: Labyrinth laid in surveyor's flags on the lawn of the US Capitol, Washington D.C. for a two-week long 'demonstration for inner peace' in March 2000.

permanent labyrinth building across the U.S.A. One recent example is the elegant Chartres replica, in smooth granite, which has been placed within its own park in the town of New Harmony, Indiana, long famous for its association with hedge mazes and with utopian movements (see picture page 69).

Another equally vigorous labyrinth movement in America has grown out of interests in dowsing (the use of divining rods to sense earth energies and underground water) and in sacred geometry. In the mid-1980s this movement was spearheaded by two Americans, Sig Lonegren, author of *Labyrinths: Ancient Myths and Modern Uses*, and Richard Feather Anderson, in association with Jeff Saward and an East Coast dowser, Marty Cain. With their help, labyrinths became regular features at conventions of the American Society of Dowsers, where workshops were taught about the use of the paths for sensing and focusing what dowsers see as the palpable energies of the earth. This led

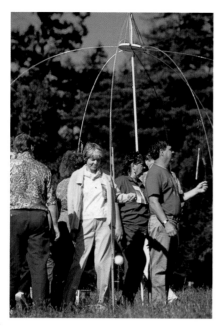

to a lot of experimentation in labyrinth design, especially with the seven-circuit 'Cretan' model.

In 1994, Jean Lutz of Scottsdale, Arizona, launched the first national publication, *The Labyrinth Letter* (no longer published) and then organized two conferences. These brought together the disparate elements of the labyrinth movement in America, leading to the formation in 1998 of a global organization, The Labyrinth Society, which now sponsors a website and a forum for the exchange of ideas and holds an international conference every year (see Resources pages for details).

Left: Dowsers try out the 'sounds' of the labyrinth at a West Coast meeting.

Below: Chartres-style labyrinth at a Catholic church beside a freeway in Bad Berneck, Germany.

Europe and Australasia

In Europe there is also a thriving modern revival in Switzerland. In the late 1980s two artists, Agnes Barmettler and Rosmarie Schmid, created a 90-foot (27 meters) wide contemporary labyrinth garden on the site of a former military academy, now called the *Labyrinthplatz*, in central Zurich, and later helped to build many pathways in Europe. Switzerland now has an organization called the Labyrinth Project International, made up of labyrinth makers and designers who create public pathways for seasonal celebrations as well as for church and community groups. Germany and Austria also have a wide array of labyrinths, both seven- and 11-circuit. A spectacular Chartres-style path can be seen at a church alongside a motorway at Bad Berneck (right). Germany maintains its historic turf labyrinths at Hannover (in the Eilenrade Forest), Steigra and Graitschen. According to Susanne Kramer-Friedrich of the Labyrinth Project International, labyrinths in Europe are often seen as ecological symbols as well as places where people can experience a way of thinking which is radically different from the 'rationalism and purely economic approach' of today's world.

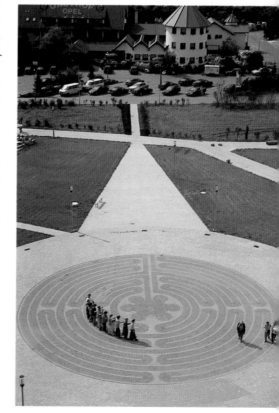

Britain currently maintains eight historic turf labyrinths, dating from the 13th century, seven of which can be easily viewed. The biggest, at 132 feet (40 metres) across, is at Saffron Walden in Essex. In addition, there are hundreds of newer labyrinths and puzzle mazes as well as historic rock carvings and a handful of Roman mosaics. Ireland has several very old carvings of seven- and 11-circuit pathways. London-based teacher and author Helen Raphael Sands has been pioneering the use of canvas labyrinths for workshops in the U.K., Ireland and France. With her 26-foot (8 metres) portable canvas path she utilizes circle-dance, ritual and movement, as well as story, to create what she calls an 'inner reflective journey' for people. She conducted a series of walks in France, the U.K. and Ireland for three years up to the new year in 2000.

Above: Labyrinth installation for an exhibition in St Pölten, Austria, January 2000.

In France there are few new labyrinths, although large mazes are cut into cornfields in the Loire Valley during summer. A small octagonal labyrinth was laid in a new cathedral at Evry outside Paris in 1995, but it cannot be walked. Recently Chartres Cathedral reopened its nearly 800-year-old path for public walking, but only in restricted hours. The reconstructed octagonal labyrinth at Amiens is likewise open at certain times. The 15th century one at St Quentin is open most of the time, and is the most accessible labyrinth in France.

Italy has a handful of historic smaller labyrinth mosaics and reliefs, in churches at Pavia, Pontremoli, Lucca and Rome, and one larger path: at the church of San Vitale in Ravenna. In Denmark and Scandinavia, thanks to the efforts of researchers Jørgen Thordrup, John Kraft and others, a major revival is taking place, mostly in schools and among community groups, which have taken to recreating traditional seven-circuit pathways in schoolyards, parks and community centers. This is mainly as part of cultural programs designed to reacquaint young Danes and Scandinavians with their heritage. Throughout Scandinavia there is a strong move to protect and preserve the hundreds of old stone models which still dot the countryside, as well as the labyrinth frescoes on church walls. Russia, too, has labyrinths—both ancient ones in stone and modern canvas models. The new ones are being used mainly by psychotherapists as part of family counseling and rehabilitation programs.

Australia and New Zealand both have thriving labyrinth communities, although there are few public labyrinths to be seen as yet. Most of the available models are on canvas or in private gardens and retreat centers. A large chartres-style labyrinth was recently built in Mullumbimby, NSW and may be the first publicly available one on the east coast of Australia. Large models have also been proposed for Canberra and Melbourne.

The Pattern of Re-emergence

Is there a pattern to the labyrinth's emergence throughout history? From our quick overview, we can say a definite yes. The labyrinth seems to appear in times of prosperity and economic growth and during periods of cultural and technological 'renaissance.' Its emergence also seems to coincide with the emergence of new religious and spiritual movements, especially mystical and contemplative ones and those that involve worship of feminine forms of deity. The bad news, however, is that it seems to precede times of trouble and hardship. In other words, it typically appears on the cusp between periods of expansion and growth and those of chaos and decline. This pattern can be seen from the first to the fifth centuries in Rome, in the 12th to 14th centuries in Italy and France and again in late 19th-century Europe. Our current period of revival reflects the initial stages of this process perfectly.

Of course periods of expansion and growth usually give way to periods of decline, just as prosperous times tend to lead to spiritual and religious experimentation. It is the labyrinth's timing within this cycle that is interesting. Does its re-emergence indicate that change is imminent, perhaps? History itself can be seen as a continuous ongoing cycle, symbolized by the image of the wheel—implied in the labyrinth's geometry—a wheel which is constantly rolling between periods of expansion and retraction, comfort and chaos. Perhaps one of the 'messages' we can take from the labyrinth is a reminder that this cycle is ever

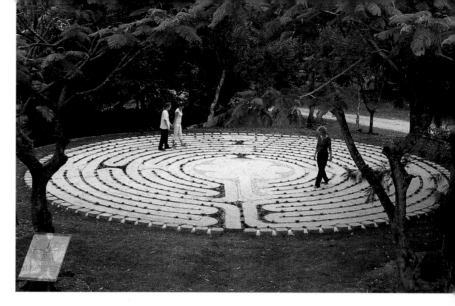

Above: The new labyrinth at the Crystal Castle, Mullumbimby, Australia.

Left: Cathedral Labyrinth, New Harmony, Indiana, U.S.A.

ongoing. We are once again in a period of growth and prosperity, in which mysticism, especially nature mysticism, and spiritual experimentation, including the revival of the idea of a goddess, are evident. We need only look at the number of books that have been published since the early 1970s on the goddess and take note of the increasing number of occurrences of visions of the Virgin Mary (including on an office building in Texas).

Another historic fact about labyrinths is that they tend to crop up following times of rapid population growth. Most of the world experienced a significant 'baby boom' following the Second World War, which has resulted today in disproportionately high numbers of middle-aged people in our societies. New York labyrinth-maker David Tolzmann thinks this is one of the main reasons why labyrinths are reappearing now, especially in America, where the baby boom generation is particularly prominent. Many members of this middle-aged group have known relative comfort and peace for most of their lives, and in many cases are only now having to face harsher realities: illness, death, the loss of

loved ones, the end of careers etc. In this age of disenchantment with traditional religious forms, do some of them see the winding paths of the labyrinth as a 'safe' alternative place for spiritual expression?

The depth of the 21st century spiritual malaise, across all generations, should not be underestimated. Dislocation and transience are common features of our societies. Many of us are becoming 'urban nomads', that is,

'Through the discipline of keeping the labyrinth I have found my deepest communion with Spirit, restoring my connection to self, others and the earth. It is where I work out all my unresolved issues, plan my work and rearrange my interior …
— *Toby Evans, keeper of the Prairie Labyrinth, Missouri* (see p. 71)

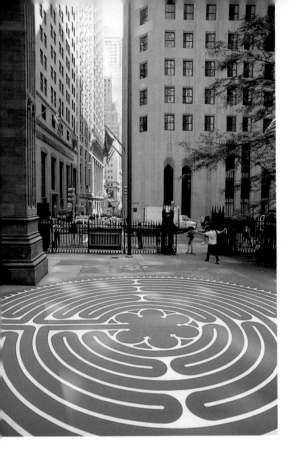

we are constantly moving in order to 'make it.' Instead of working fewer hours, as was predicted in the mid-20th century, we are working longer and harder than ever. Advanced technology has made for greater speed of communications but also greater pressure and stress. Throughout all Western nations, rates of divorce and suicide are at record levels.

If you listen to some modern enthusiasts, there appears to be an almost inexhaustible list of benefits gained from walking labyrinths. The path is recommended for relaxation and healing and for dealing with the stresses of modern life. So it is taken out from under the dark vaults of cathedrals, from forest floors and remote hilltops and put instead into the dazzling light of public squares, schoolyards and hospital courtyards. Is this a good idea though? Once divorced from their sacred settings and secluded environments, labyrinths can lose some of their power to affect us. This has been demonstrated in America, where new ones in park and recreation areas may stand neglected when there is not sufficient community understanding or energy to maintain interest in them and when they are placed in open environments, not conducive to either meditation or healing. Surrounded by flowers and cheerful decorations, the empty labyrinth glints mournfully in the sunlight. Worse, some are subjected to inappropriate use—by skateboarders or as platforms for market stalls.

Have we forgotten their ancient meanings? … The coiled snake, the winding dance of death and rebirth, the sacred marriage, the sacrificial god, the cave of the underworld? A labyrinth may not be quite the 'universal spiritual tool' which some have called it. Neither is it a cure-all. It is a device for going deep. The Greeks told us so and the Romans did too. In tying it to a path of salvation in the Middle Ages our forebears might have inadvertently given us the wrong

Labyrinths are now found across America, from Wall St, New York (above) to the Makaha Labyrinth, Hawaii (right), built by former university professor Neal Pinckney after his recovery from heart disease.

impression. Those who seek quick truths, enlightenment or 'salvation' in a labyrinth's path may be bound for disappointment.

The enthusiasm for labyrinths today is exciting and heartening. It indicates, perhaps, a return of 'soul' and of some community spirit. However, in our modern rush to find new uses for this ancient device, let us be careful that we find appropriate uses for it and that we do not 'whitewash' it or take away its mystery. For what are great symbols without the mystery and awe that make them live in our imaginations?

IN ALL SHAPES AND SIZES ...

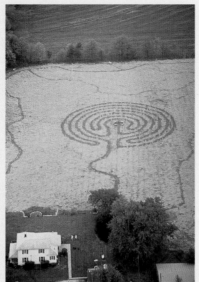
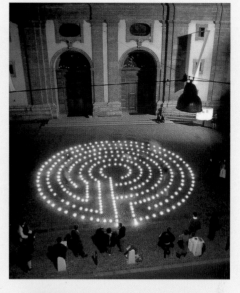

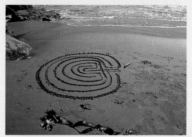
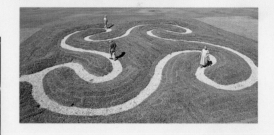
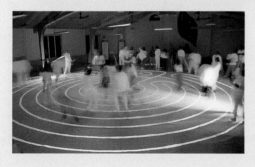

Labyrinths in various media, from top left to right: canvas, prairie grass, candles, stone, ice, sand, turf mounds, flour, gravel, fluorescent paint and food cans.

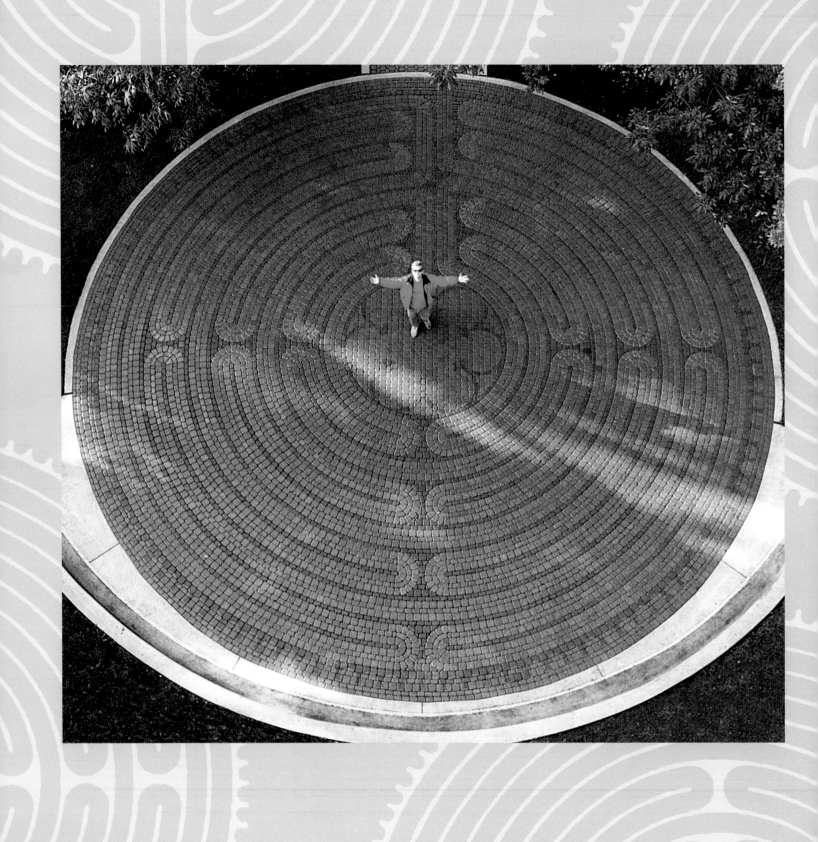

7. CUNNING DESIGNS

The past decade has seen major innovations in labyrinth design. Two styles predominate: the seven-circuit 'classical' or 'Cretan' one and the 11-circuit 'Chartres model.' But there are beginning to be variations on both themes. There are now seven-circuit Chartres types and five- and 11-circuit 'Cretans', 'Chartresfied Cretans' (a Cretan model with concentric circles) and labyrinths made in the shapes of crosses, stars, polygons, roses and knots. Some are drawn on canvas or vinyl, some on concrete, others are traced onto sand. Permanent models are made from stones, crushed granite, bricks or tiles, while others are created from mounds of earth covered by turf or bark. Costs vary widely. A canvas path can be created for around US$1200. Large permanent paths in brick, tile or terrazzo can cost around US$75,000 or more. Many labyrinths, however, are made using cheap or freely available materials such as river stones and pieces of wood.

With demand increasing, especially in the United States, labyrinth making has become a full-time profession for some people. Here are some of the world's leading designers:

Above: Labyrinth finger tool designed by Sue Anne Foster, U.S.A.

Opposite: Marty Kermeen in the labyrinth he designed at Naperville, U.S.A.

Below: The Santa Rosa labyrinth on outdoor carpet.

In St Louis, Missouri lives the world's most prolific labyrinth maker, Robert Ferré (left) who, since 1995, has turned out more than 400 pathways in fabric, stone, cement and acrylic resin, ranging from 12 feet (3.7 metres) to 104 feet (31.7 metres) in diameter. In recent years he has added two new models: a seven-circuit Cretan/Chartres hybrid called a Santa Rosa labyrinth (below), designed by Lea Goode, and a small 12-foot (3.7 metres) personal labyrinth. Ferré draws the canvas models sold by Veriditas in San Francisco. The founder of the St Louis Labyrinth Project, he is the author of several do-it-yourself labyrinth-making manuals and co-editor of *Through The Labyrinth*, by Hermann Kern. He has been a presenter at conferences and events throughout the U.S.A., in Canada and in Chartres, France. Director of One Heart Tours, he has led pilgrimages to France since 1989, including private labyrinth walks in Chartres cathedral. His two-day workshops include lectures on sacred geometry and ceremonial uses for the labyrinth. Ferré mainly sells his labyrinths to church and community groups, therapists and workshop facilitators who use them for group work and to help open up people emotionally and spiritually. 'The labyrinth is a great tool for spiritual and healing work,' he says.

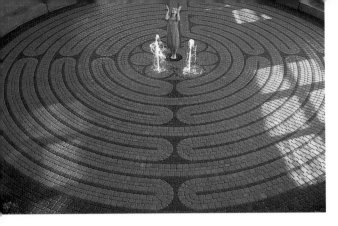

*Above: Labyrinth at
Long Beach, California.*

Pavement artist Marty Kermeen, from Illinois in the U.S.A., creates large outdoor labyrinths by laying down a mosaic of brick or natural stone tiles, piece by piece, like a giant jigsaw puzzle. Each brick has to be shaped to the intricate design and the work is slow and painstaking. It requires complex geometry, mathematics and a lot of concentration. Kermeen is regarded as a world expert in the technique. He has been hand-sculpting pavers for more than a decade; it is a process, he says, which takes him into a meditative state at times. He makes labyrinths for churches, universities, corporations and community groups. Recent clients have included the City of Naperville, Illinois, and churches in Long Beach, California and Shreveport, Louisiana. He believes the labyrinth is coming back because people are hungry for more 'communal spaces' where they can come together and share experiences. The labyrinth is linked to the journey of the soul, he says.

California-based designer Victoria Stone uses her dual background in health care and design to create large permanent labyrinths mainly for hospitals but also workplaces and people's homes (below left). Her first was a full-size Chartres model for the California Pacific Medical Center in San Francisco (below right), completed in 1997. Since then she has designed labyrinths for several medical facilities around the U.S.A., including Morristown Memorial Hospital in New Jersey (see plan, right). Recently, she designed a 16-foot (5 metres) labyrinth for the center of a Nautilus-shaped 'serenity garden' at Doylestown Hospital in Pennsylvania, and has consulted on another at the Samuel Stratton Veteran's Hospital in Albany, New York and in the Penrose–St. Francis Hospital in Colorado Springs, CO. She is currently working on a personal labyrinth healing tool. Stone regularly consults with nursing staff about the use of labyrinths in the hospital environment. She believes the path is a 'wonderful tool for healing', adding that it helps people to 'remember the wisdom that resides within.'

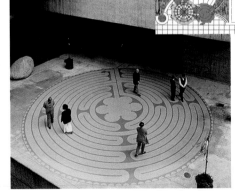

On the west coast of the U.S.A., earthwork designer and dowser Alex Champion has been making seven-circuit Cretan labyrinths from turf-covered mounds for parks and recreation areas as well as for private clients for about 12 years. Today, his work has expanded. He now makes earthworks in the shapes of flowers, wands, five-, six- and seven-pointed stars, crosses and from meander patterns and spirals. One path is based on a pattern from an ancient Viking horse blanket (right). He recently created a personal, six-foot (1.8 metres) long, healing and meditation mat in a pattern he calls the 'meander wand' (top right). As a dowser, he is interested in what he perceives as energy patterns that arise in locations in which labyrinths are placed. Labyrinths have completely changed his life, he says. He believes they are good devices for getting in touch with the healing and revitalizing energies of the earth and for connecting with Spirit.

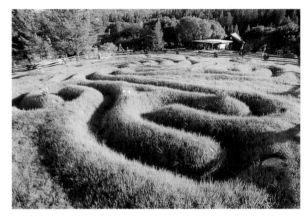

In Baltimore, Maryland, David Tolzmann makes canvas and washable acrylic and nylon labyrinths in several designs and sizes, as well as outdoor permanent models in both seven and eleven circuits, and he, too, is busy. His portable labyrinths include a unique convertible octagonal model (right) which he designed for the Jersey City Alliance to Combat Drug and Alcohol Abuse. It has a removable inner panel and can be five or nine circuits, depending on the space available. He also offers the Baltic wheel and classical Cretan labyrinths. He has built outdoor ones in concrete pavers for large hospitals, such as the Johns Hopkins Medical Center and St Paul's School in Baltimore, as well as for churches, such as St Anthony of Padua, Baltimore (right). It takes him about a day to lay down the pattern in acid stain. In 2000 he put an acrylic canvas Chartres model outside Trinity Church on Wall Street in Manhattan; it is currently being walked by office workers and tourists. He believes that the labyrinth is 'good for calming the mind in a crazy world', and thinks that it is coming back because more people are seeking ways to be spiritual.

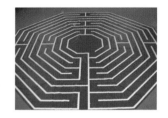

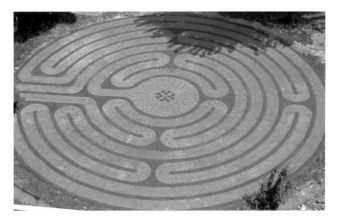

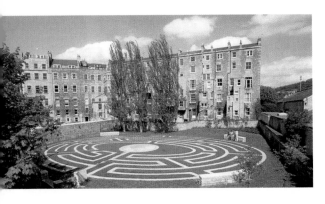

In Britain lives the world's leading designer of mazes, Adrian Fisher. Since the 1980s he and his company have created hundreds of mainly puzzle mazes—in palaces, stately homes, museums, amusement parks, universities and shopping malls—across five continents. His paths, which are made of everything from hedges to plastic tiles, marble and mirrors, have won numerous awards and some are in the *Guinness Book of World Records*. Some are designed along the lines of the classical hedge and garden mazes of the 17th–19th centuries, some have more symbolic designs, and most are puzzle mazes and for fun, although Fisher also

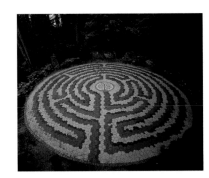

designs single paths like the Tree of Life (right) and others that have a dual multi-path/single-path structure and are intended for contemplation. These include the famous Bath Festival Maze (top left), the Archbishop's Maze at Henley-on-Thames and the highly innovative Tudor Rose pattern at Kentwell Hall. Fisher is intrigued by the challenges of creating new patterns, and he believes mazes and labyrinths are good for bringing people together. 'They're great for families,' he says.

Further north in Scotland, Jim Buchanan is a land artist who has been experimenting with labyrinth forms for some years. In 1997 he created, for the city of Chesterfield in Yorkshire, the world's largest seven-circuit labyrinth—an earth mound nearly 400 feet (122 metres) wide, whose path runs three-quarters of a mile each way (below right). Utilizing 7000 tons of soil from a nearby excavation, it was then covered with wildflowers, and is now as much an ecological statement as a walkable path. Another unique design (below left), created for a forestry service in Galloway, simplifies the Cretan labyrinth down to just three circuits. Buchanan is currently transferring his skills

with large-scale land art into labyrinths of light and sound, locating these in places that are associated with Scotland's history of pilgrimage. He believes that labyrinths should reflect the unique qualities of their locations and he sees them as instruments for reconnecting people to nature.

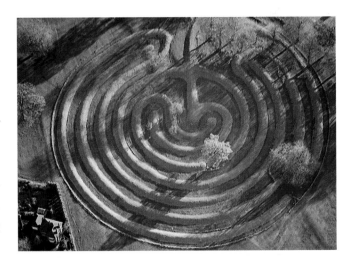

The Switzerland-based Labyrinth Project International is made up of groups of mainly women designers who create labyrinths in their local communities both in Switzerland and in other parts of Europe. Several models are used, including standard seven- and 11-circuit pathways and the Baltic Wheel pattern, but many pathways are a contemporary mix of these styles. Gardens are incorporated into the labyrinths and the paths are lined with flowers and herbs. The designers believe in making labyrinths to suit their locations. Their aim is to create green and pleasant spaces for people to come together to celebrate the seasons, the cycles of the moon, solstices and events in the Christian calendar. Some see the labyrinth as a symbol closely associated with nature and with the ancient earth Goddess.

Above: Labyrinth in Zurich's Labyrinthplatz, Switzerland.

Gernot Candolini is an innovative labyrinth designer from Innsbruck, Austria, who likes to experiment with new forms and to make labyrinths which meet specific needs and purposes. In 1996 he created a 'sunwheel' floral labyrinth (below right) for a park in central Innsbruck. On another occasion he made a temporary labyrinth from cloth wound between trees, for a psychiatric hospital. He has also designed a range of canvas and vinyl labyrinths which he calls 'Jacob's Dances' (below left), which are inspired by the path of pilgrimage. His specialty, however, is a candle labyrinth, which he sets out in public squares and parks at night during festivals such as Easter, Midsummer and St Martin's Day. A biologist by profession and author of a recent book, *Das Geheimnisvolle Labyrinth*, he regularly conducts seminars and events. He likes to let the path unfold its own mystery within people. 'It seems to be able to take us into very deep levels … It speaks to people and they love it,' he says.

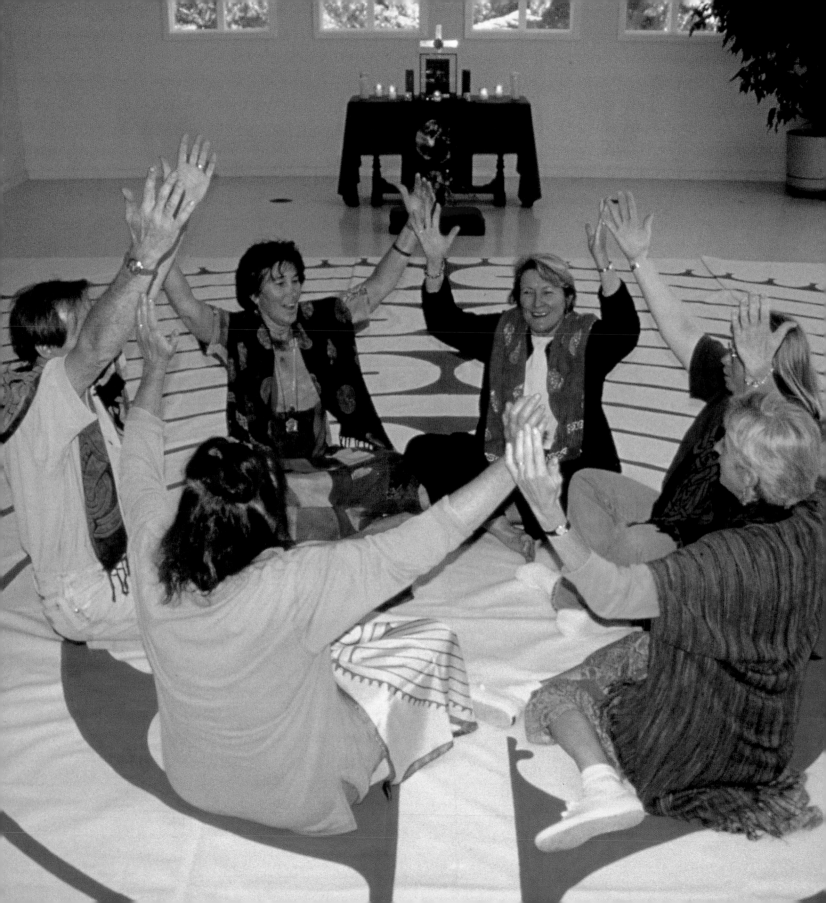

8. SPIRITUALITY AND HEALING

Love has taken away my practices and filled me with poetry … — Jelaluddin Rumi

It is a fine Saturday in San Francisco—near Union Square, shoppers, buskers and street people jostle for space on the sunshine-spattered pavements. Everyone seems to be hurrying in straight lines, like arrows, towards their destinations: department stores, restaurants, bus stops and traffic lights. On a hilltop above them, meanwhile, another kind of procession is taking place, only it is circular and much slower. Within the cool, concrete walls of the city's largest church, a few people are walking a labyrinth. They are doing so mostly with eyes cast down and in silence, their feet plodding in measured steps around a winding pathway marked on carpet. Some are praying or silently repeating mantras, some are quietly musing, watching others or simply enjoying the feel of the carpet beneath their feet.

A few have walked a labyrinth before, many are doing it for the first time. A middle-aged woman walks to mark the end of her chemotherapy, a man with HIV wants to celebrate his birthday, someone mourns the loss of a friend, another just wants to feel relaxed. A woman, wearing a crystal around her neck, walks so that the child she is carrying can experience what she believes is the protective magic of the ancient device. All are strangers who have come together in the winding coils of the labyrinth.

For many people, especially in the U.S.A. and Canada, a labyrinth is first and foremost a spiritual device, a place for finding deeper meaning in life or for encountering the Divine, in whatever form they conceive of it, for spiritual renewal, inner peace and transformation—our modern word for 'salvation', perhaps. Labyrinths are seen as places for prayer, meditation, spiritual healing and sometimes revelation.

Today, pathways are to be found, mainly in Protestant churches, in just about every major American city. Accordingly, a church is often the place in which many Americans have their first encounter with a labyrinth. In Europe, Britain, Canada, Australia and New Zealand, you are more likely to see one in a park, a retreat center or a community hall. Within churches, labyrinths are viewed as a form of community outreach, and as a way to encourage more people to come inside. Grace Cathedral in San Francisco was the first Episcopal church in America to install a permanent labyrinth—it now has two: one inside and one outdoors. It was encouraged to build them (from donations) after it saw literally hundreds of people lining up to walk a temporary canvas model on one New Year's Eve.

Below: Going around in circles … the winding path may produce subtle neurological effects that facilitate deeper states of consciousness, say some researchers. Chartres Cathedral, France.

Opposite: A healing circle in a labyrinth, California, U.S.A.

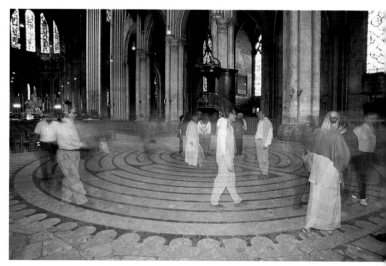

Above: Dancing Goddess labyrinth in the home of Marty and Debi Kermeen, Illinois, U.S.A.

For priests and ministers, labyrinths are seen as important aids to more kinesthetic or body-centered forms of prayer, including dance and ritual, which are becoming popular in some churches. As one minister put it, 'People don't just want to sit in church and listen any more, they want to *do* something, they want to be part of the liturgy.' For Grace Cathedral, the labyrinth has also been an important exercise in ecumenism, as it has forged strong ties between it and the French Catholic home of the original labyrinth, Chartres. Chartres Cathedral recently reopened its 800-year-old path for walking, mainly because of American interest.

Spiritual experiences are very common within labyrinths. Walkers sometimes report quite intense mystical states, including union with a divine force or communion with 'spirit energies.' Some manage to resolve longstanding problems or grief or struggles with issues related to relationship and forgiveness. For others, walking a path becomes a way to reconcile themselves with the church and with past hurts. After one labyrinth walk in a church, a woman wrote: 'I saw the interior of St Luke's (her church) in a completely new light. I saw beauty and warmth. I was shown that if others see us through God's light they will not get hung up on the defects and past hurts. They will see the beauty that is within … what a blessing this walk has been!'

Sometimes the inspiration to work with a labyrinth comes as a kind of spiritual revelation or 'calling.' In the case of a former marketing manager, Rebecca Rodriguez from Texas, this happened in a dream which she had while hiking the Inca Trail near Machu Picchu in South America in 1997. In it, she saw an unfamiliar circular shape, which at first she thought was a Native American 'medicine wheel' but later recognized as the Chartres labyrinth. It was sitting on a ledge overlooking a lake. In her dream Rodriguez heard a voice telling her that it would appear within two years and would be 'sacred.' She returned to her newly purchased home on Canyon Lake in Texas and proceeded to create a Chartres path on a specially constructed wooden platform above the lake. She ran her first event with it two years to the day from the time of her dream, she says. Today, she uses the labyrinth for private

'I love running through water but running through a labyrinth is almost as good … it helps you think straight.' — labyrinth walker

workshops on spirituality and for 'women's wisdom circles.' She says the labyrinth has been part of a spiritual journey which has completely altered her life.

Right: Rebecca Rodriguez's Labyrinth of the Lake, Texas.

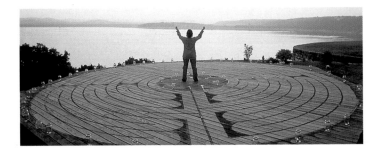

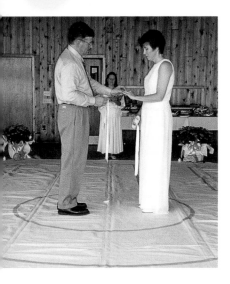

'WE GOT MARRIED IN A LABYRINTH ... '

In her home town of New Canaan, Connecticut, interfaith minister Helen Curry uses a three-circuit labyrinth of her own design in which to conduct weddings. Groom and bride are each blessed and wished well by their families before they separately enter and walk the path to the center. Here they take their vows and emerge from the labyrinth as a couple. Curry says the symbolism of walking the labyrinth—representing the path of life—first by themselves and then as a couple is very moving. The labyrinth also provides a spiritual 'container' for the ceremony that seems to add a deeper sense of meaning to the event. She is being asked to perform more weddings this way. Labyrinths are used for other rites of passage too—Christenings and naming ceremonies, anniversaries and rituals associated with commemoration or mourning.

Healing Labyrinths

When an art therapist and teacher, Sue Anne Foster, of Sacramento, California discovered she had cancer in 1993 she was already building a labyrinth of brick and rocks in her backyard. Upon getting the diagnosis and being told that she had between two and five years to live, she began to walk it every day, sometimes several times a day. She spent a lot of time in the labyrinth, she says. It helped her to feel calm and to center herself for the all-important battle against the disease, although, as she is quick to point out, 'battle' is a word that she has since dropped from her vocabulary. The labyrinth taught her about going with the energies of nature and not trying to make things happen. It taught her about acceptance, she says. It also took away her fear. 'I am much more *still* these days,' she adds. 'I don't push the envelope.' Seven years after diagnosis, she has no further symptoms.

Above left: Helen Curry performs a wedding.

Below: Sue Anne Foster's backyard labyrinth in Sacramento, U.S.A.

The labyrinth was just one of many strategies that helped her to get well, she thinks, and it also helped her marriage. Communications with her husband improved in the course of building labyrinths together. Since her illness, she has designed several new pathways, including her latest, which she calls the 'healing earth tree labyrinth' (next page). Currently she collaborates with therapists, teachers and healers to offer workshops and classes in the use of the labyrinth.

Today, hospitals across the U.S.A. are installing labyrinths in their grounds, not just for patients but to help staff deal with the pressures of working in a busy medical environment. Some, like the one at Sparrow Hospital in Lansing, Michigan, are contained within their own 'meditation gardens' to give them a much-needed sense of enclosure and to create a peaceful, sacred atmosphere. Nurses, doctors and paramedic staff come to walk in times of stress and when emotions run high from overwork or grueling encounters with tragedy. Cancer patients and those about to undergo surgery also find the labyrinth a way to keep calm and composed and to

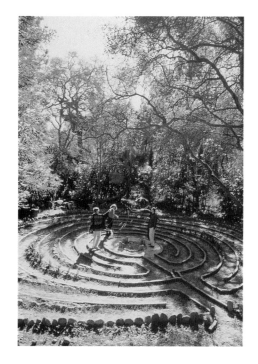

better deal with the crisis they are facing, according to hospital authorities. A few patients report rapid rates of recovery, which they attribute to the labyrinth's effects.

Hospital labyrinth designer and health-care educator Victoria Stone, from San Francisco, tells how ambulance paramedics sometimes walk the path at the California Pacific Medical Center in order to deal with their distress after attending serious accidents. 'The labyrinth seems to help them to release grief and despair and to find a place of renewal,' she says. Stone, who consults with nurses and physicians at hospitals to train them in the use of the labyrinth, says the pathway is good for healing because 'its three stages of release, opening and integration are the same stages we go through in any healing journey.' Through the labyrinth, she says, we reconnect with our inner healing potential. She believes that educating nurses and doctors about the labyrinth is essential if the increasing number of pathways within hospitals are to be used effectively.

At the Johns Hopkins Bayview Medical Center in Baltimore, Maryland, a very old labyrinth design, in seven circuits, has been placed in a garden next to the Geriatrics Center. Here it is walked by patients as well as their families and by staff, who often slip out during a lunch break. The 60-foot (18 metres) wide labyrinth has paths big enough for wheelchairs. It was funded by a grant of US$85,000 from the Annapolis-based TKF Foundation, which supports the establishment of what it calls 'open spaces, sacred places'—communal areas for the experience of spirituality and inner peace.

Labyrinths are also being used to fight drug and alcohol abuse. In New Jersey, the Jersey City Alliance to Combat Drug and Alcohol Abuse has acquired a collection of portable paths which it loans out to schools, rehabilitation centers, hospitals and other institutions for use within treatment and education programs. Counselors use the devices to facilitate discussion about emotional issues which have led to abuse. Many find the labyrinth a useful tool for 'getting to the bottom' of drug problems.

A healing or calming effect also seems to apply when labyrinths are used in palliative care and in hospices for the dying. Canadian palliative care nurse Ruth Richardson, from Nepean, Ontario regularly offers labyrinth walks to groups of people struggling with serious illness, and finds that it helps them to become more tranquil and also to make important decisions about their treatment and other matters. She recalls an elderly man who came to walk a labyrinth one evening, just a few months before his death. He talked of discovering, in its turns, a metaphor for the issues which he felt he needed to resolve with his friends and family before he died. For months afterwards he told his children about the 'amazing path' he had walked and how it had helped him to acknowledge and 'put right' all issues between him and them. 'His family told me that it completely transformed those last months of his life,' she says. At his funeral, mourners were given pictures of a labyrinth in honor of the peace he had found there.

Above: Healing Earth Tree by Sue Anne Foster.

Below: The Johns Hopkins Bayview Medical Center labyrinth in Baltimore, U.S.A.

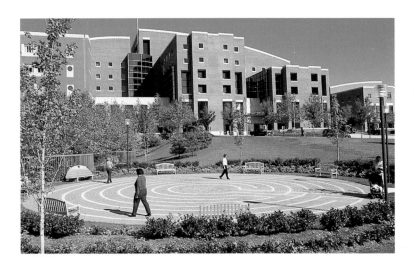

Richardson, who has been nursing for 21 years, has seen some important transformations in people after they have walked her temporary paths, which she often creates in hockey tape on the floor of a local church hall. There have been some unusual cases, too, such as one in which a woman walked her labyrinth and experienced a pain in her head and slight nausea. The incident sent her to a doctor who diagnosed a brain aneurysm which was picked up before it could do major damage. While she had been having headaches beforehand, the labyrinth walk seemed to bring it to her attention at just the right moment. In spite of stories like this, Richardson does not believe that the path holds any special magic. 'It's just tape on the floor,' she says but it seems

Above: Labyrinth in cloth at a psychiatric hospital in Austria. Gernot Candolini designed it to illustrate how treatment is experienced by patients.

Left: Lone walker on the Theosophical Society labyrinth at Wheaton, Illinois, U.S.A.

to 'call people to be more present in body and in spirit. It opens us up to all shades of the mystery and it opens the heart in a way that is easy.' Sometimes that can be a major help in times of grief and bereavement. She has had many people tell her that they have sensed the presence of deceased relatives and friends in the heart of the labyrinth, an experience which many of them found 'overwhelming but wonderful.' Richardson currently teaches nurses about the labyrinth. She feels that it is being accepted by a wide variety of groups in Canada and thinks that the path is coming back because Westerners are longing for more 'mystery' and sacredness but without dogma.

In Grass Valley, California, licensed psychotherapist, spiritual director, and teacher Lynn Goodman has been using labyrinths to facilitate what she calls 'healing and spiritual growth' among those who attend her workshops and open walks. Goodman thinks of the labyrinth as a kind of 'energy transformer.' What people experience in it very much depends on what they bring to it and what they need to heal. 'A walk, like any meditative process, can range from calm, peaceful contemplation to

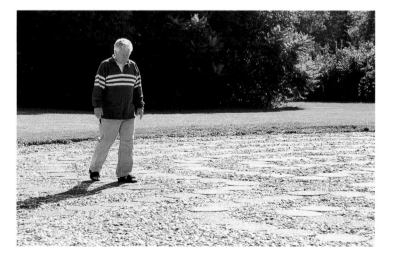

intense emotional or mental insight, a sudden "aha", ecstatic bliss, or dark night,' she says.

Some people are disturbed by the resurfacing of memories, old wounds or what therapists call 'shadow material' (that which is repressed or denied in their personalities). 'As the labyrinth contains or holds this energy, they find themselves suddenly walking through what they have feared or avoided,' she says.

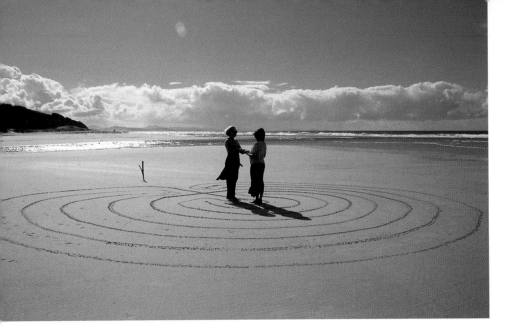

For some walkers, such confrontations can be unexpected and surprising. I vividly remember a woman coming to me after her first labyrinth walk and telling me that she felt as if her skin was crawling 'with things trying to get out.' She seemed agitated and fearful. It turned out that she had had a history of abuse. I advised her to keep walking the labyrinth, which she did. Each successive walk proved to be more and more calming, until one evening she reported an experience in which she had a vision of a man standing in front of her. Afterwards she wrote: '… and when I stood before him he

Above: Labyrinth on a beach, Byron Bay, Australia.

Below right: Neal Harris of Illinois, U.S.A. and his 'Intuipath' finger labyrinth.

smiled down on me. Reaching into his chest he removed his heart and placed it lovingly into the void within me. A warm glow spread throughout my body and a beautiful blue light shone through my skin, lighting a glow all around me …'

Lynn Goodman has had some dramatic moments in labyrinths too. One was in the center of the pathway in Chartres Cathedral in France; while looking at one of the stained-glass windows, she was suddenly overcome with a powerful 'surge of collective grief' which felt like not just her own but that of all creation. 'It was as if all the buried pain in that place suddenly welled up,' she says.

In her workshops, she allows time for group 'processing'—talking about feelings and experiences—both before and after labyrinth walks. She thinks that this is important for ensuring that people are not overwhelmed. She also does guided meditations and ritual blessings and encourages people to write down their experiences. She has seen the labyrinth help people through major life transitions such as divorce and grief over a loved one's death and thinks it works especially well with those who have

'The sadness of old childhood hurts were replaced by peace and light |and the many petalled rose …'
— labyrinth walker

suffered trauma or abuse. 'Often these people have core fears held in their bodies. They may be depressed, anxious, dissociative, or emotionally numb,' she says. The labyrinth seems to help transform some of these symptoms by releasing pent-up tensions and repressed emotions. 'It helps rebalance and recover lost parts while opening one to the presence of the Divine … the labyrinth is a very powerful container for helping people with their inner process.' How does it work? She does not like to analyze this too much. The labyrinth is a mystical tool, a sacred place for contacting the 'infinite mystery at the core of our very being', she says.

Nevertheless, there are some who believe that walking the path produces subtle neurological effects, which facilitate healing and deep

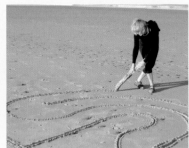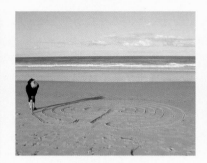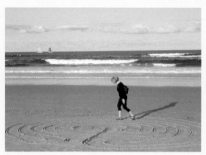

states of consciousness. Neal Harris, a licensed counselor and teacher from Barrington, Illinois, says recent British research has indicated that a labyrinth may affect brain-wave activity in some users. 'This research shows a short-term increase in mental clarity in some people with Alzheimer's, schizophrenia and dyslexia, as well as greater mobility in some who are suffering with Parkinson's disease,' he says, though he is quick to add that the effects have not been studied long-term. In addition, walking a labyrinth seems to make reaching the meditative state easier for certain people, he says.

Harris has designed a number of finger labyrinths—pathways carved into wood or other materials designed to be traced with a finger (see picture opposite). Using them helps people to experience the benefits of a labyrinth meditation when they cannot walk one. 'From a psychological perspective, I believe that labyrinths help some people tap into Jung's notion of the collective unconscious,' says Harris. 'Thus, greater insight and understanding may become consciously available to them as they are working on their issues. At the entrance, the labyrinth poses a question to our rational minds, "Can the intuition come out and play?" If the rational mind agrees, it then relinquishes control to intuition … which is far more knowing.'

ENCOUNTER IN A LABYRINTH …

One day, when I was feeling particularly turbulent and sad, I decided to walk the labyrinth. As I went in, I couldn't really get my mind to quiet. Thoughts and ideas were jumbling around inside me. When I reached the center, I sat down. Suddenly, I had a sensation of sliding down a long tunnel, deep into the ground. I found myself in an underground space, like a cave, where I sensed a presence, very strong … maybe I should have been scared but I wasn't. In fact, I felt strangely at ease. After a while, I was overcome with a deep sense of comfort, as if someone had put their arms around me. It was really wonderful. Then in my head I heard a voice say: 'You are mine' … I can't begin to describe the peace and joy I felt in that place. I didn't want to leave but eventually I noticed my friend finishing her walk and I felt I should go. I have held that deep, comforting presence and those words in my heart, ever since. — *an account of a walk in a labyrinth*

Labyrinths in Prisons

This was a great experience … I felt the leaving of burdens in the labyrinth. I felt the presence of the Holy Spirit while I was in prayer and when I left the center I felt a newness of life within me. A very awesome feeling. — county jail inmate, California

'Before walking I felt hate and anger towards many people. After, I feel at ease deep inside and pray to God that I continue to feel this way.'
— county jail inmate, California

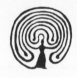

In the U.S.A., labyrinths are being taken into a small number of prisons, jails and youth detention centers for the purposes of opening up dialogue between counselors and inmates and for providing those who are incarcerated with some form of spiritual nourishment.

At the Monterey County Jail in California, the Reverend Deacon Peggy Thompson regularly organizes labyrinth walks for inmates. Of the 1000 who are there, some have just been arrested, others have been at the jail for months. Many are in for minor offences, others face more serious charges, and some are heading for life sentences in State or Federal prisons. She is often amazed by what she describes as 'the bravery' of men who are prepared to walk and show their emotions in front of each other. Tears are common and some get unexpected answers to questions while walking the labyrinth, she says. Many appreciate it because it is seen as 'free space', a place where they can go by their own rules and be themselves. Says Thompson: 'I'm often surprised by how open they are.' Women inmates, surprisingly, are less responsive to the labyrinth, she reports.

She is equally amazed by how well the jail authorities have accepted the device. Two years ago she managed to convince the Inmate Welfare Board to buy the canvas path in a way that she sees as nothing short of the 'work of the Holy Spirit.' While skeptical about it, board members confessed later that they suddenly felt 'compelled to vote for it.' Thompson is trying to build up credibility for her program so that labyrinths can be taken into other jails. Why does she think it works in prison? 'For a lot of people here, prayer seems a one-sided conversation, fruitless. The labyrinth teaches them how to listen for the answer to those prayers.'

On the other side of the country, Helen Curry and members of the Labyrinth Project of Connecticut Inc. take a canvas labyrinth to the Federal Correctional Institution at Danbury, CT for a regular group walk that includes the women inmates talking about their experiences before and after the event. Facilitators get them to set an intention for the walk and they usually form a circle around the labyrinth for a short prayer and blessing beforehand. Poetry and scripture passages are sometimes read. Often important insights arise about what is going on for them and why their lives have turned out as they have, says Curry. The labyrinth walk seems to be quite centering, and offers an opportunity for the women to express their feelings and hopes.

Labyrinths in Schools

Schools also have been keen to adopt the labyrinth in America, Canada and Australia. An historic independent girls school, Havergal College, in Toronto, Canada, recently laid a seven-circuit path in an auditorium to 'help soothe and calm our very busy school atmosphere', as a teacher put it. In the U.S.A., St John's Episcopal School in Baltimore recently put a seven-circuit path in a quiet corner of its grounds so it can be walked by teachers and students for reflection and 'de-stressing' during exam times and other periods of pressure.

Labyrinth building is now part of some school programs, especially in Scandinavia, where students learn how to create several different designs as part of cultural studies and to engage their interest in

Scandinavia's ancient heritage. In drawing and constructing the paths, they also develop skills in teamwork and problem solving and they get to express their creativity. For these same reasons, labyrinth building has been taken up by several American schools. In Santa Fe, New Mexico, the Labyrinth Resource Group has come together to help schools design and construct pathways, including providing dowsers to choose sites and to lay out the labyrinths. The Group has many suggestions for how labyrinths can be used, including for conflict resolution, special celebrations and for creating bonding between classmates and teachers. They urge schools to supervise students and teach them about the proper use and purpose of the labyrinth, however, so as to prevent the kind of inappropriate use pictured left. Children who walk labyrinths are more relaxed, less angry and frustrated and they gain insights for solving problems the group claims. Some children also seem to get relief from grief and emotional trauma.

Annette Reynolds, of the Labyrinth Project of Alabama, has been using a labyrinth as part of 'grief camps' to help youngsters deal with the loss of loved ones. The children learn about the life and death cycle of nature and gain comfort from walking the path together, she says. Meanwhile, at a youth center in Sebastopol, California, an outdoor labyrinth has been constructed as part of programs to help troubled teenagers deal with their problems, and especially as a way to soak up excess energy and calm overactive minds. The labyrinth is proving to be an excellent 'chill out' device, say some counselors.

Above: Labyrinth in a school playground in Køge near Copenhagen, Denmark.

Left: Inappropriate use— a skate boarder in a school labyrinth, California.

Below: Temporary labyrinth made from food cans at a Country Day School in St Louis, U.S.A.

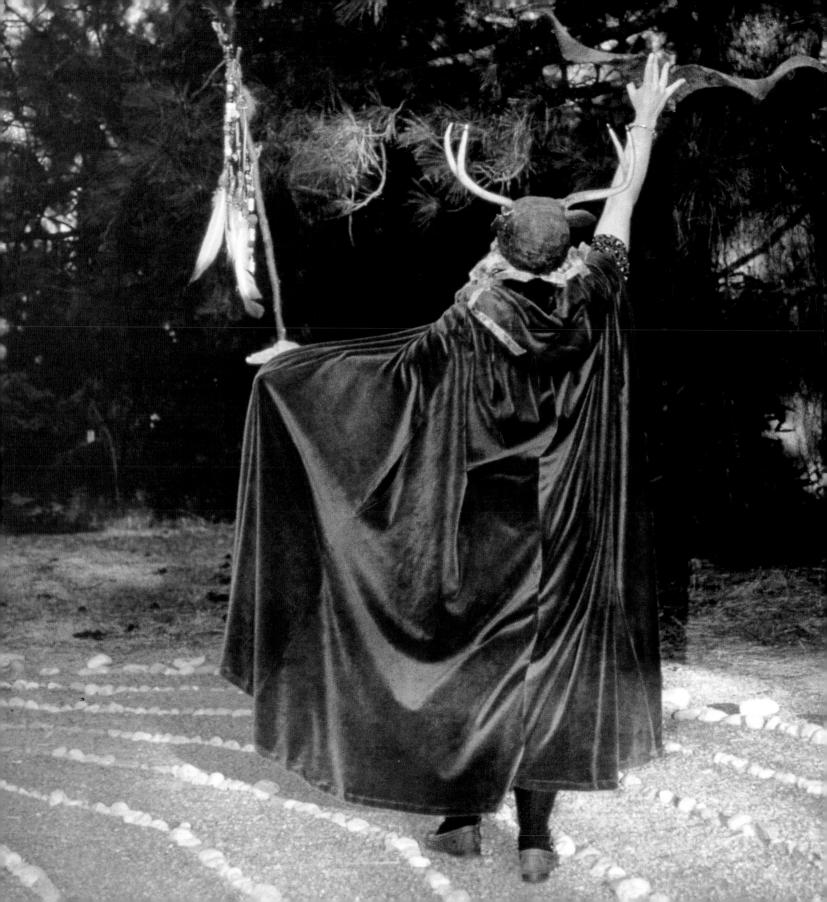

9. LABYRINTHS AND EARTH MYSTERIES

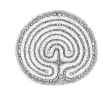

How can you tell if you have had a meaningful experience in a labyrinth? Often by the vivid dreams you have afterwards, the strange sensations you feel in your body, sudden confrontations, sometimes days later, with an insight or truth that hits you between the eyes. All are standard manifestations of the 'energy' contained in these ancient devices, according to Alex Champion, a dowser and professional labyrinth maker.

Champion has been experimenting with earthworks and labyrinths for 12 years, ever since he quit his job as a biochemist in Berkeley and took off for the green hills of Mendocino County, California, to become a full-time 'earthworks artist.' These days, he designs labyrinths and other large earth sculptures, and he has produced two books: *Earth Mazes* and *Essays on Labyrinths and Other Geometric Symbols*. For Champion, as for many practitioners of earth-based spirituality—dowsers, goddess worshippers, neopagans—the path is first and foremost a device for sensing and focusing earth and other energies and for connecting to the spirits which he believes are present in nature.

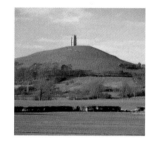

Above: Glastonbury tor — a giant labyrinth?

Opposite: Earthworshipper honors the ancient spirits of nature in a labyrinth in California, U.S.A.

Below: Gathering in Zurich.

Around the world, labyrinths are being used by an increasing number of spirituality groups for rituals and seasonal celebrations such as solstices and equinoxes. In Europe, earth worshippers walk them to connect to the wisdom of an ancient goddess whom they believe is the source of all creation. On a solstice night in Zurich, people sometimes gather around a labyrinth on fire to celebrate their connection to her and to nature. In southern England, meanwhile, you are likely to see, on any day, dozens of people slowly toiling up the terraced paths of Glastonbury's famous tor, which many believe to be a prehistoric labyrinth, built to honor the sun or some other cosmic deity of a bygone era. Protests by archaeologists that the terraces are merely the work of sheep do not seem to dampen the ardor of the walkers, who frequently trace the paths to the summit as an act of pilgrimage.

In many parts of America, too, neopagans are embracing labyrinths as platforms for ritual and celebration. At a recent event in California, one such group dedicated a labyrinth they had built to the spirits of truth, peace and compassion. Wearing cloaks and animal masks, they processed solemnly to its center, where they passed around a cup of wine, signifying the blood of an ancient god of sacrifice and rebirth, whose journey, they believe, is symbolized by the path.

Since the 1990s, Alex Champion has been conducting labyrinth walks at dowsers' gatherings on the West Coast, encouraging people to experiment with the 'energies' within the paths. He believes that labyrinths are extremely good focusing devices for

earth energy. Their very shape and geometry offer a connection point between matter and spirit, he says. Some dowsers experience dizziness, tiredness, warmth, tingling and other bodily sensations while walking labyrinths. While not always pleasant, they are evidence that 'energy is present' and that 'something is happening', he thinks. Often it means that a spiritual healing is taking place, he adds.

Champion has had some dramatic experiences in labyrinths himself, including a strong visceral sense of connection to one ('I could feel a cord, literally between me and the labyrinth,' he says), vivid dreams, feelings of euphoria, visions, or aches, pains, and sudden feelings of exhaustion. He is a firm believer that the paths have done him nothing but good, however. 'I am healthier, happier and more at peace than I was before I started this work. Things don't bother me as much and I don't judge people the way I used to,' he says. Often, challenging feelings arise after labyrinth walks or after he has used his latest creation, the six-foot (1.8 metres) long meander wand, but he believes negative feelings only represent 'barriers we need to get through.' As proof, he points to a pile of testimonials from people claiming that they have been healed of everything from colds to intense pain, thanks to the use of the meander wand and other devices. One woman claimed that her vision improved substantially after she walked an earthwork labyrinth, he says.

Using a single L-shaped metal divining rod, Champion always 'dowses' or 'asks the local spirits' where to locate the center point of any new labyrinth which he is about to build. He senses it by subtle feelings in his hands or in other parts of his body. He then lays out the labyrinth by standard methods, using a compass and straight edge to mark the lines. He believes that three-dimensional paths are more

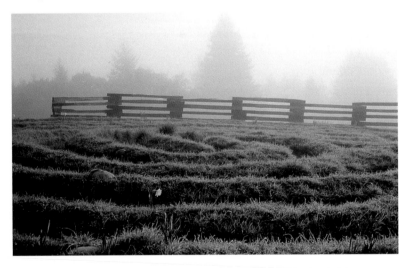

powerful than flat models drawn on the ground. Within them he discerns two types of energy—concentrated 'spots' and subtler lines. For him, the labyrinth has opened a doorway to spiritual experience that has transformed his life and left him feeling more at peace. He likens it to 'an orchestra of tuning forks vibrating with the energies of the geometric forms of nature …'

Above: Earth worshippers in a labyrinth, California.

Below: U.S. dowser John Wayne Blassingame at work in a labyrinth.

Right: Dawn on Alex Champion's labyrinth, California.

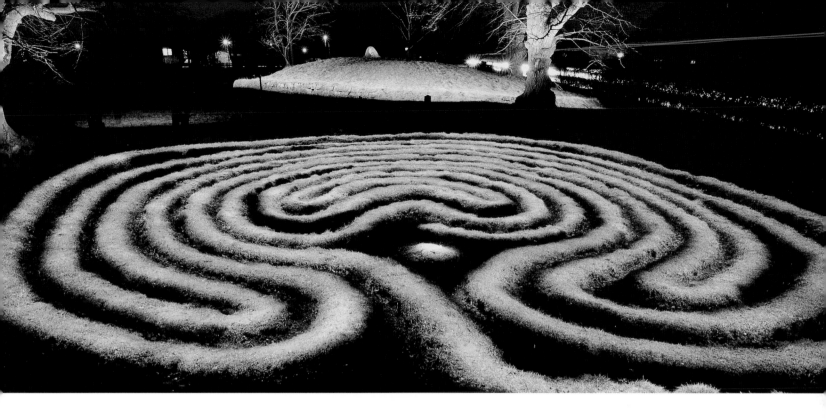

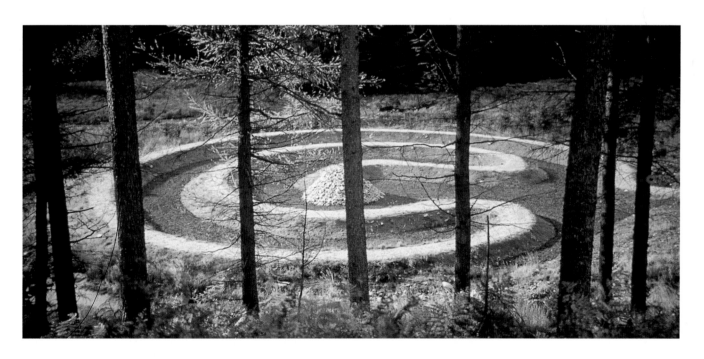

Top: Labyrinth painted in light, Steigra, Germany. Bottom: Labyrinth in the Galloway Forest, Scotland, by Jim Buchanan.

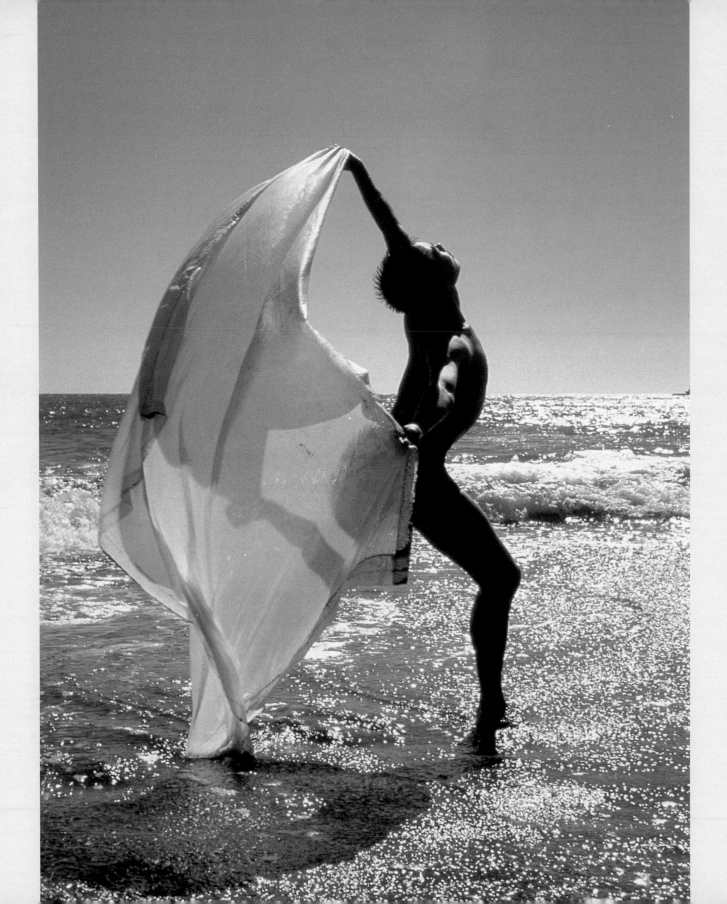

10. LABYRINTHS IN ART

When Theseus killed the Minotaur and escaped from Crete, legend tells us that King Minos grew so angry he imprisoned the mythical maker of the labyrinth, Daedalus, and his son Icarus inside the device. Daedalus managed to fashion wings for himself and his son to fly out. Unhappily, though, Icarus flew too close to the sun; the wax of his wings melted and he plunged into the sea. The fatal flight has been the subject of paintings and sculpture for centuries, and recently, members of the Marin Ballet Company danced their version of it on a beach in California.

For thousands of years, it seems, labyrinths have inspired artists and performers, especially those interested in portraying the inner landscape of human emotion and experience. Today, dancing in labyrinths is becoming a common sight once again. Spiral and other ritual dances are regularly performed on labyrinths around the world. In Scandinavia, maypole dances are held in spring, and in England, too, Morris dancers sometimes perform on top of turf labyrinths. In the U.S.A. and Canada a growing number of dance companies are being inspired to create what some call 'moving prayer' inside labyrinths. The performers use the paths to create new forms and patterns of movement based on the shapes of circles, triangles and crosses, all inherent in the labyrinth's geometry. In Baltimore, Maryland dancer/choreographer Nancy Romita and her troupe, the Moving Company, regularly perform in labyrinths, especially on the large one at the Johns Hopkins Bayview Medical Center, which Romita helped to create. She believes dance can be a powerful inspiration for healing within hospital communities. In the labyrinth she aims to create 'sacred space' that allows everyone to express

Left: On a California beach, dancer John Lam performs a piece inspired by the flight of Icarus.

Below: Members of the Marin Ballet Company perform inside a labyrinth.

their 'inner dance.' At the dedication of the Johns Hopkins labyrinth, she and her troupe created a special performance called 'Pathways' (see next page), accompanied by Indonesian Gamelan music and an original score by a Maryland composer.

Meanwhile, labyrinth designs are also being featured in jewelry and clothing, in mosaics and decorations, in architecture, painting and sculpture. In the American southwest can be found jewelry and baskets featuring a native ancestral figure, the 'Man in the Maze.'

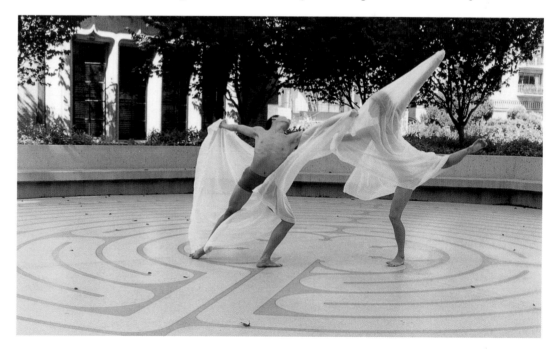

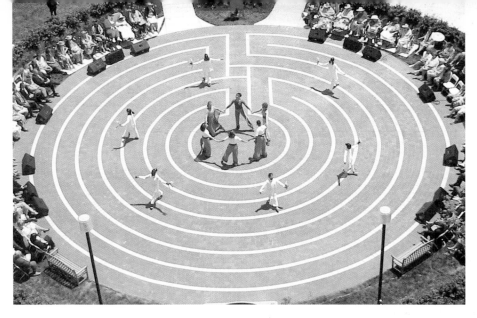

Some artists are working with labyrinths made of unusual materials. A Scotsman, Jim Buchanan, who has created several large earthwork labyrinths in Britain, is currently experimenting with making ones purely in light and sound. He wants to locate these inside historic Scottish sites associated with pilgrimage, such as cathedrals, castles and abbey ruins. Buchanan likes to make his labyrinths from the raw materials of nature—soil, grass, flowers and leaves, which disappear back into the land, in time. 'I like ephemeral work that has low impact on the environment,' he says.

Above: The Moving Company perform on the Johns Hopkins Bayview Medical Center labyrinth.

Below: Sandra Wasko-Flood and her installation 'The Dance of the Labyrinth.'

He is not the only one experimenting with labyrinths this way. In Washington D.C. an American artist, Sandra Wasko-Flood, has created an interactive labyrinth installation under glass which is designed to be walked. The path is made up of large photo transparencies in glass boxes surrounded by computer-programmed lighting and wall hangings. The design is based on a combination of the spiral and the seven-circuit path. The visitor walks on pressure-sensitive glass towards a central mirror (where they can see their own face) and to a mirror ball. The path contains composite images of icons, people, mummies and animals, superimposed to show the 'single reality uniting all existence.' The idea, according to Wasko-Flood, is to 'dance with opposites.' Her aim is to offer her audience a 'multi-sensory journey uniting art and life, darkness and light.' The piece was partially inspired by the great kiva in Chaco Canyon, New Mexico. The 'Dance of the Labyrinth', as Wasko-Flood calls her installation, is close to downtown Washington and is available for workshops and performances.

The earth itself has always been a good canvas for labyrinths and mazes. Each summer, in the Loire Valley of France, Isabelle de Beaufort and Bernard Ramus create vast pathways covering several acres of maize and corn fields. When Isabelle was a girl, she often played in the old garden labyrinth of the nearby castle of Villandry, and it was this experience, she says, which inspired her to create large designs in maize fields.

Every year there is a new theme. In the picture opposite, a series of patterns depict the planets with Saturn in their center. Within the Saturn maze there are nearly two miles of paths. Artists, representing fabulous beings, help the visitors to find the way through. The gardener (inset opposite page) walks on stilts so that he could overlook the maze and anyone lost inside. Thousands of tourists visit the 'maize mazes' every year.

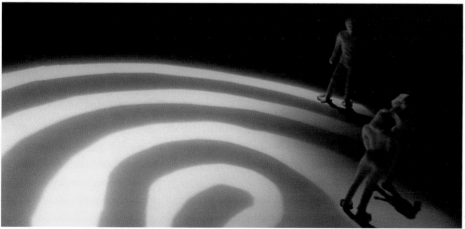

Top: Mazes in summer in the
Loire Valley, France.

Inset: The gardener on stilts
overlooks the maze.

Left: Jim Buchanan's prototype
labyrinth in light.

EPILOGUE

Beloved, when I awoke this morning, I saw a leaf fall softly to the earth
And softer still, I heard you call … calling me back to myself

Those lines, written in 1995, came to me during a period of confusion in my life and at the start of what was to be a long, deep journey through a labyrinth of my own. At the time I did not know that my turmoil would lead me to a literal labyrinth, one that I would encounter years later on a cathedral floor in San Francisco, but I see now how it did. When a labyrinth enters your life it is a sign, I have come to believe, that change is afoot and that strong forces are at work within you. This is not the case for everyone who walks one, of course, but it is for some. Labyrinths have an uncanny capacity to change lives. They are devices of depth. Entering them can be an adventure that leads us into many possibilities and many truths.

In times past, the labyrinth seems to have taken people, metaphorically at least, to the center of the world. Today, it seems to take many of us into the center of our own being. One of the best things about it, I believe, is that it offers, if we listen carefully, a reflection of what is going on inside us. It shows us our own hearts and where we are at. It brings us back to ourselves.

Labyrinths seem to be returning to our midst because we have again perceived a need for them. Our imaginations have reinvented them and given them new meaning and forms. As we have seen, they have a tendency to come back in times of affluence but also of social and spiritual upheaval, when our human spirits seem to flag under the weight of all we have created and built, when it all just becomes 'too much', perhaps. Does the labyrinth's reappearance now signal that this is such a time? If so, what does it warn us that we need to do?

After years of study, I have come to the conclusion that this ancient pathway is primarily a tool for compassion. This is what the original story about the sacrificial god, the Minotaur, hints at. In making us aware of our own suffering, it can help us to see into the suffering hearts of others, to forgive and to accept. These are not easy qualities to come by in our narcissistic, solipsistic world. For this reason I am convinced that labyrinths should be placed in the basements of any building where human affairs are decided, which of course means just about all buildings. More importantly, we need to learn how to use them again, how to awaken our compassion as we walk and not just relax or feed our narcissistic desires to become more 'efficient' and more functional. At the moment, the knowledge of how to awaken compassion in a labyrinth or anywhere else is thinly spread, but the presence of the paths in our midst once again means that this skill, too, is coming back—at least so we can hope.

As I said in the beginning, the only truth about labyrinths is that they contain no one truth. Ambiguity, tolerance, acceptance of multiplicity, of many beliefs, of variety and change are ironically the 'messages' of a pathway which is not multiple but singular. Think about that contradiction. It is at the core of the secret of the labyrinth. In the one is the many and in the many, one.

PILGRIM'S PROGRESS

Pilgrimage is a time-honored method for achieving spiritual and psychological renewal. In the Middle Ages, pilgrims took to the road to make the often difficult journey to a sacred shrine in order to show faith, atone for sins or to win salvation. Along the way, they faced many challenges and dangers, yet for some, the journey itself became as spiritually worthwhile as the eventual destination.

Today, in our high-pressured world, more and more of us are seeking 'time out' to rediscover ourselves and to find new meaning in life. Some of us are taking to the pilgrim's road once again, discovering that a journey to a sacred site can become a voyage into the truth of our own hearts.

Labyrinths are now to be found around the world. As in medieval times, they constitute a pilgrim's path that can be traced from city to city, country to country. What follows is a guide to some of the world's most unusual, beautiful and historic labyrinths. Most are publicly available and all can be walked. Our journey begins on the West Coast of the United States and takes us through Canada, Britain and finally Europe.

USA and Canada

For links to hundreds of other U.S. and Canadian labyrinths see The Labyrinth Society at www.labyrinthsociety.org

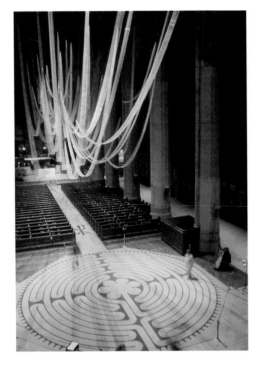

Grace Cathedral San Francisco

The labyrinths at Grace Cathedral were the first to be put permanently into a church in America. They were built in 1996 and 1998. Both are Chartres types. The one inside the church is on a carpet tapestry and measures approximately 36 feet (11 metres) across. The outdoor model, measuring 40 feet (12 metres) in diameter, is in terrazzo stone. It can be accessed 24 hours a day. Both labyrinths were funded by donations. They have been walked by an estimated one million people from around the world. Grace Cathedral has a monthly taizé service by the labyrinth with live music and candles, and also a New Year's Eve labyrinth walk.

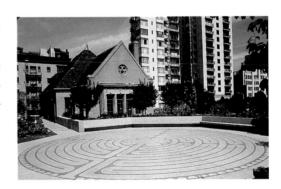

Grace Cathedral, 1100 California St, San Francisco, CA 94108, USA
Tel: (415) 749-6358

Earthwork Labyrinths, Philo, California

Earthwork designer Alex Champion has several fine labyrinths on his property in Mendocino County, California. These include his famous Viking Horse Trappings Maze and a 62-foot (19 metres) wide Cretan labyrinth, and the newly created 140-foot (43 metres) long 'flower wand.' The labyrinths are constructed from earth with sunken paths and elevated mounds, and covered with grasses and flowers. Every spring, Alex and his wife Joan host an annual 'daffodil party', when people are invited to come and experience the energies of spring in the labyrinths. Labyrinths are for viewing and walking by appointment only.

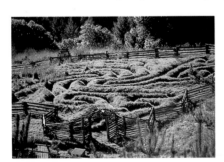

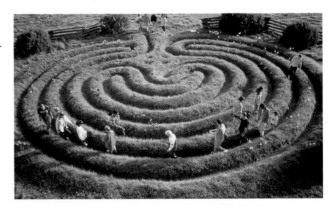

Contact: Alex and Joan Champion, PO Box 145, Philo, CA 95466, USA
Tel: +1 (707) 895-3375
earthsymbols@earthlink.net

Cathedral Labyrinth, New Harmony, Indiana

An architect-designed labyrinth in polished granite has been laid in a garden in the town of New Harmony—long known for its hedge maze and for utopian social experiments. Both labyrinth and garden were designed to match, as closely as possible, the sacred geometry of Chartres Cathedral, France. The 42-foot (12.8 metres) path is a very close replica of the one there. It sits beneath a canopy of trees, framed by an avenue representing the nave at Chartres and beckoning the modern pilgrim towards its heart. Trickling nearby is the Orpheus Fountain, in which the visitor can wash his/her feet before or after entering. The labyrinth was dedicated in 1997 and was funded by The R.L. Blaffer Trust and Jane Blaffer Owen.

Cathedral Labyrinth and Garden, North St, New Harmony, Indiana (near the Atheneum); PO Box 581, New Harmony, IN 47631, USA
Tel: +1 (812) 682-3050

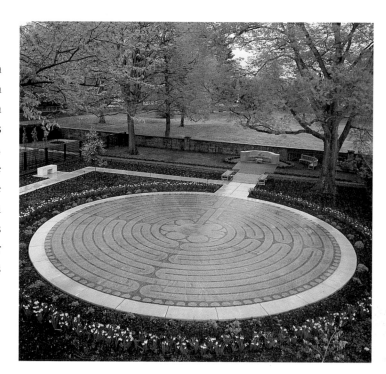

Millennium Labyrinth, Naperville, Illinois

This beautifully constructed labyrinth, built by Marty Kermeen, lies beside a river, near downtown Naperville. It was dedicated in September 1997. The City of Naperville Celebration 2000 committee raised the money for it along with help from the park district. The idea was to leave something of historic significance to mark the new millennium. Built of red and brown concrete paving stones, the Chartres style labyrinth is 40 feet (12 metres) in diameter. It is situated next to the river walk and is surrounded by gently sloping terraces and pine trees.

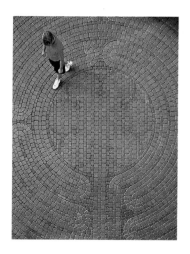

Riverwalk Park, Naperville, IL, USA (near the south east corner of the Jackson St bridge) Contact: Debi Kermeen
Tel: +1 (630) 552-3408; email: artpaver@aol.com

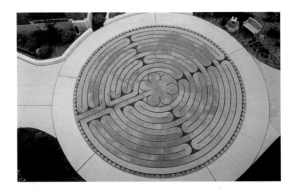

Sparrow Healing Garden, Lansing, Michigan

An elegantly designed Chartres-style labyrinth in granite, set in its own healing garden lies at Sparrow Hospital, Lansing. Currently being used as a sanctuary for the 'nourishment of the soul' by hospital patients and staff and members of the public. Funded by grants from the National City Bank and community members. Open all the time.

Sparrow Hospital, 1215 E. Michigan Ave, Lansing, MI 48912-1811
USA Tel: +1 (517) 483-2700
website: www.sparrow.com

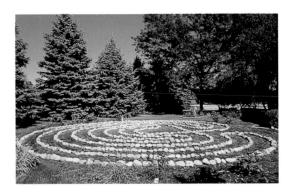

Provena Wellness Center, Elgin, Illinois

Part of St. Joseph's Hospital, Elgin, this center specializes in many different programs for fitness and health. Its 36-foot (11 metres) mulch and fieldstone seven-circuit labyrinth was the first hospital-affiliated permanent labyrinth in the Midwest. Hours: Sunrise to sunset daily. Located at the center on Hawthorne near Larkin, across from the bank.

Provena Wellness Center, 100 South Hawthorne St,
Elgin, IL 60123, USA. Tel: + 1 (847) 622.8289

Prairie Labyrinth, Sibley, Missouri

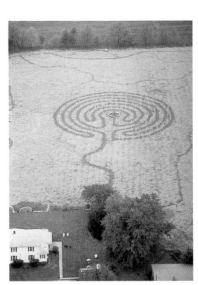

This seven-circuit labyrinth is mown into a field which has been planted with native grasses as part of a prairie restoration project. It was created by Toby Evans and Mary Barge in 1996, who dowsed the site. It is now used by groups and individuals for workshops and private walks. It has 'gateway posts' at each turn, which represent chakra energies, and is open by appointment.

Contact: Toby Evans, 1316 N. Holly Rd, Sibley MO 64088
USA Tel: +1 (816) 650-5474
email: prairie@thincmissouri.org

Johns Hopkins Bayview Medical Center Labyrinth Baltimore, Maryland

This unusual seven-circuit labyrinth based on a ninth-century design has been created in pavers at this historic Baltimore campus, by David Tolzmann. Sixty feet (18 metres) wide and big enough for wheelchairs, it sits in its own garden and is open to the public. Located next to the Geriatrics Center.

Johns Hopkins Geriatrics Center, 5505 Hopkins Bayview Circle, Baltimore, MD 21224, USA. Tel: +1 (410) 550-0289

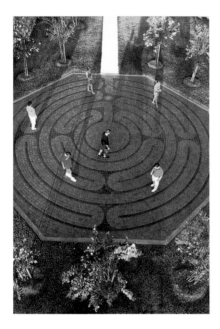

St. Luke's Methodist Church, Shreveport, Louisiana

A 37-foot (11 metres), seven-circuit 'Santa Rosa' labyrinth was built by Marty Kermeen in 2000. The labyrinth is surrounded by trees and rests in its own prayer garden behind the church. Buff and charcoal concrete paving stones were used to create it.

St. Luke's Methodist Church, 6012 Youree Drive, Shreveport, LA, USA. Contact: Mamie Huffman Tel: +1 (318) 797-7283

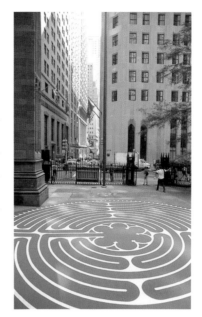

Trinity Church, Wall St, Manhattan, New York

This Chartres-style labyrinth, painted on acrylic canvas by David Tolzmann, is glued to the south plaza at the head of Wall Street. Installed as an experiment before the church proceeds with a more permanent model, it is currently walked by local office workers and tourists.

Trinity Church, Broadway & Wall St, 74 Trinity Place, New York, NY 10006, USA. Contact: Reverend Gay Silber Tel: +1 (212) 603-0800

Bells Corners United Church, Nepean Ontario, Canada

This labyrinth, in Nepean, on the outskirts of Ottawa, Canada was created as a joint community and church effort. Local businesses provided bricks and cement at low cost, individuals donated their time and money. The Rev. Grant Dillenbeck (right) laid the last brick in September 1999. The Chartres-style, 42-foot (12.8 metres) path in colored interlocking paving stones is open all the time and is wheelchair accessible. It is one of about 50 permanent labyrinths across Canada.

Bells Corners United Church, 3955 Richmond Rd, Nepean, Ontario, Canada
Tel: +1 (613) 820 8103; email: office@bcuc.org website: www.bcuc.org

Karen's Living Labyrinth, Hammond, Ontario

Karen Brousseau has created a 57-foot (17 metres) 'living labyrinth' out of flowers. She has also built an 80-foot (24 metres), 11-circuit turf path which she likes to walk in winter. The seven-circuit labyrinth represents earth energy, she says, while the 11-circuit labyrinth connects her to the heavens. She walks it when she needs to work on 'issues.' Both are open by appointment.

Contact: Karen Brousseau, 3085 Bouvier Rd, Hammond, Ontario, Canada. Tel: +1 (613) 487-3604

UNITED KINGDOM

For information about these and other British labyrinths contact the British Tourist Authority or check out www.labyrinthos.net

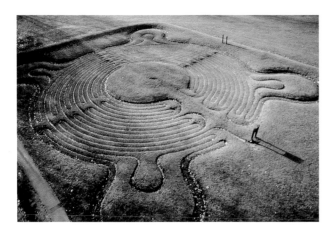

Labyrinth, Saffron Walden, Essex

At 132 feet (40 metres) across, this is the biggest of the old turf 'mazes' in Britain. It came from a design borrowed from a 16th century garden pattern book and was cut in the 17th century. Folklore says young men would wager beer as to who could first reach its center and a girl standing there. Morris dancing is sometimes held on its central mound today. Its path, which runs nearly a mile each way, has 17 circuits, including the four bastions, which stand midway between the compass points. The entrance faces due north.

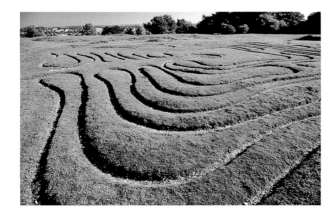

St. Catherine's Hill 'Mizmaze', Winchester

A very unusual square labyrinth of nine circuits lies atop a steep hill with splendid views over the Hampshire downs. It is thought to have been cut by schoolboys from nearby Winchester in the late 17th century. St Catherine's Hill is an ancient site of human settlement. It once had an Iron Age village and locals have used the hilltop for games and dances on festivals like May Day, for centuries. The labyrinth path, which is very narrow, is cut into the turf rather than lying on top of it, as in most other British turf models.

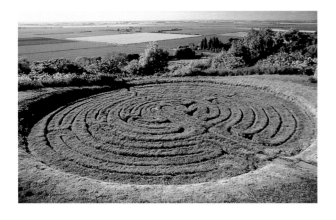

'Julian's Bower', Alkborough, Lincolnshire

The origins of the name of this labyrinth are obscure, but it seems likely that it has been here since the 13th century when legend says monks from a nearby monastery built it. The design corresponds closely to the Chartres pattern but with a smaller center. It probably served as a model for many other Chartres-style turf labyrinths in Britain. It is in a magnificent location, atop a ridge overlooking fields. There is a record of it once being called 'Gillian's Bower', after a popular girl's name.

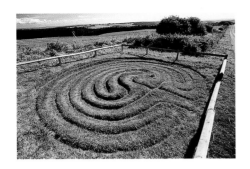

Dalby, Yorkshire

A 'Troy Town' turf labyrinth of seven circuits dating to the mid-19th century — lies inconspicuously beside a road near Dalby, next to open expanses of heathland. It suggests a connection to the stone labyrinths of Scandinavia and hints at possible Viking influences from the past.

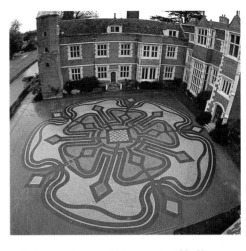

Tudor Rose Maze, Suffolk

This unique and spectacular maze/labyrinth, in the form of a Tudor rose, is at historic Kentwell Hall near Long Melford. It offers a five-fold unicursal path as well as a puzzle maze. Its center contains a giant chess board. Designed by Randoll Coate and Adrian Fisher in 1985.

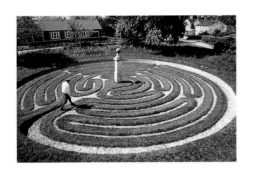

Breamore, Hampshire

This 11 circuit pathway sits in a secluded grove of trees, atop a hill on which have been found remains dating to Neolithic times. It is about a mile walk from the nearest road and has a special 'magical' atmosphere. It was possibly used for rituals, dances and games in the past.

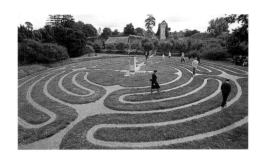

Hilton, Cambridgeshire

A beautifully preserved Chartres-style turf labyrinth, probably originally 11 circuits, now just nine, thanks to inaccurate re-cutting. Laid in 1660, a stone pillar in its center commemorates the builder, William Sparrow. 'Fleeting are the glories of the world', says an inscription.

Archbishops Maze, Henley-on-Thames

Located in the grounds of Grey's Court, and inspired by a sermon of an Archbishop of Canterbury, this combined unicursal/multicursal path is full of Christian symbolism. Meant to represent the 'path of life', in its center is a pillar with inscriptions from Augustine to Siegfried Sassoon. Designed by Coate and Fisher in 1981.

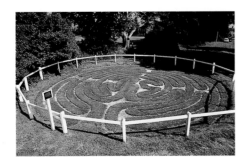

Wing, Rutland

This attractive and well-maintained path is 11 circuits and of the same design as Alkborough and many others. It lies close to the parish church of this quaint English village. Nearby was once a Bronze Age tumulus, indicating that the area probably had religious importance in the past.

FRANCE

For information about these and other French labyrinths, contact the French Government Tourist Office.

Amiens Cathedral

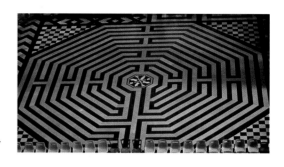

Located in an historic town in the heart of the French battlefields of the First World War, just an hour north of Paris, Amiens Cathedral has a magnificent octagonal labyrinth in black and white stones. Originally laid in 1288, then torn up in the early 19th century, it was rebuilt around 1897. In its center is a plaque showing the figures of the architects and bishops who built the cathedral. The cross that once sat in its center was aligned to the compass points, and its axis to the point where the sun rises on the Feast of the Assumption, August 15. The labyrinth is open only at certain times.

Notre Dame Cathedral of Amiens, Somme France

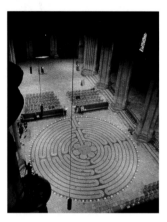

Chartres Cathedral

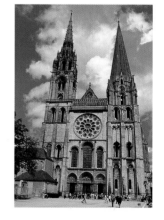

Chartres Cathedral lies atop an outcrop of rock, said to be a site of druid worship in ancient times. The church has been a center for pilgrimage since the ninth century. On view is its famous relic—a piece of cloth said to be part of the Virgin Mary's veil—plus a black Madonna who is an object of veneration. Underneath is the largest crypt of any Gothic cathedral, dating back to the 10th century. The labyrinth is the oldest walking-sized Christian path in the world. It is 42 feet (12.8 metres) in diameter, and has a unique rose center and 112 crenellations around the outside. It is open for walking only during certain hours in summer.

Notre Dame de Chartres, Eure et Loire, France

St. Quentin Basilica

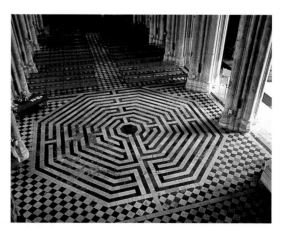

This is the most accessible labyrinth in France. Laid in 1495, it is in the octagonal shape of the Amiens labyrinth and is composed of blue–black marble and white stone. Its center is a plain dark octagon. Unlike others, this church is quiet and peaceful and the labyrinth is almost always open. Next to Chartres, it is the second-oldest intact pavement model in France. St Quentin's Basilica was heavily bombed in 1917, but the church and its charming labyrinth have survived.

Collegiate Church of St Quentin, Picardy, France

ITALY AND SWITZERLAND

For information about Ravenna contact the Italian Government Tourist Office. For a full listing of Swiss labyrinths see: www.labyrinth-project.ch/index.html

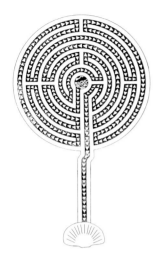

San Vitale, Ravenna, Italy

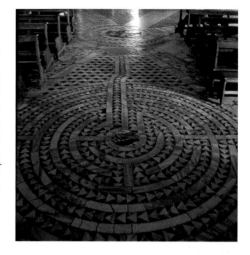

This remarkable black and white labyrinth, in a unique design, was laid down in the 16th century. It is part of a much larger octagonal pattern that lies beneath the central cupola of this 6th century church in Ravenna. With seven circuits, the labyrinth has arrows along its path, perhaps indicating the direction to be walked—outwards from its center towards the middle of the octagon. Possibly it was intended to serve as a path of ritual cleansing or shedding of sins, before entry to the heart of the church. It may have also symbolized rebirth.

Church of San Vitale, Ravenna, Italy

Academy of Boldern, Männedorf, Switzerland

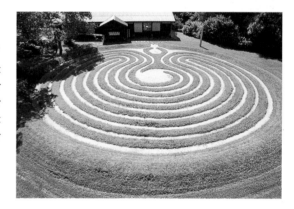

This cheerful modern turf pathway of nine circuits is modeled on the famous 'Rad' labyrinth in Germany. It is in the 'Scandinavian wheel' design, which allows an exit straight from the center as an alternative to walking back out and so is useful for processions. It sits in front of the Japanese pavilion at the Academy of Boldern near Lake Zurich and has the feel of a 'Zen garden.' Wheel designs reputedly were built by Swedish soldiers in Germany in the 17th century when they were used for ceremonies, including weddings and baptisms.

Academy of Boldern, Evangelisches Tagungs-und Studienzentrum Boldern, Pf., CH-8708 Männedorf; Tel: 01-921-71-11 website: www.boldern.ch

Labyrinthplatz, Zurich, Switzerland

This labyrinth is based on the award-winning design for a public space by two Swiss artists Rosmarie Schmid and Agnes Barmettler. Around 90 feet in diameter, it was laid down during the early 1990s on the site of a former military academy about ten minutes from Zurich's central train station, and today is walked by people visiting the square as well as women's groups and nature lovers. The outer circuits are composed of flower beds and shrubs. The inner area is a seven-circuit pathway.

Labyrinthplatz, Zeughaushof im Kasernenareal, Zurich. Pf., CH-8135 Langnau a/A website: www.labyrinth-project.ch

GERMANY AND AUSTRIA

For information about many more German labyrinths see http://home.t-online.de/home/labyrinthe/index.htm
For Austrian ones contact: candolini@eunet.at

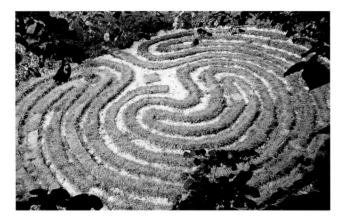

'Schwedenring' – Steigra, Thuringia, Germany

A spring festival with dancing is still held on this well preserved 11-circuit turf labyrinth beside a road at the northern edge of the village of Steigra. Reputed to have been built by Swedish soldiers during the Thirty Years' War, its name means 'Swede's ring', but it is sometimes also called 'snake's path.'

Querfurt Bundestrasse, DO6268, Steigra, Germany

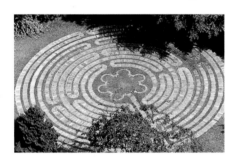

Augsburg, Germany

Father Heinz Naab of the Franciscan Center initiated the making of a Chartres-type labyrinth in bricks in the garden. Bricks were taken from an old oven at the monastery, used in times of hardship to bake bread for the poor.

Franciscan Center, Sebastianstr. 24, D86153 Augsburg, Germany

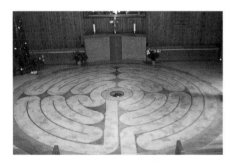

Scheidegg, Germany

Minister Peter Bauer had this labyrinth built in 1999 after his epic 1000-mile pilgrimage (see Chapter 1). Sculptor Max Schmelcher from Scheidegg designed and made it in stone. It sits in a church in a spa town and is often walked for healing. Open 24 hours.

Contact: Peter Bauer, Evangelische Auferstehungskirche, Am Hammerbach D88175 Scheidegg, Germany

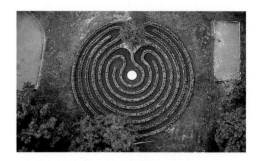

Innsbruck Labyrinth, Austria

Built of flower beds by the City of Innsbruck and designed by Gernot Candolini, this labyrinth is based on a ninth-century manuscript and features a tree in its center and also a mirror. The idea is that the spiritual life begins by looking at oneself.

Open all year, free entrance. Stadtpark Rapoldi 6020 Innsbruck, Austria.
Tel: 0664 1818809

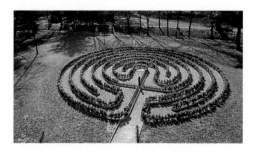

Bad Tatzmannsdorf, Austria

Built in 1996 from an idea by Gernot Candolini, this seven-circuit labyrinth was inspired by the hedge mazes of the 16th–18th centuries.

Open all year. Kurpark Bad Tatzmannsdorf 7431 Bad Tatzmannsdorf, Austria.
Tel: (03) 353-8284.

SCANDINAVIA

There are literally hundreds of stone labyrinths in
Scandinavia, many of them dating back 500 years and
beyond. The three featured here have been chosen for their
accessibility and interest. For more information contact
Labyrinthos: www.labyrinthos.net

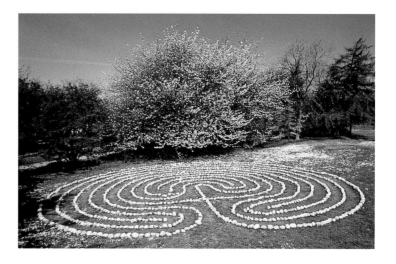

'Trojaborg', Valby, Copenhagen

Trojaborg means 'Troy Town.' This modern stone
labyrinth at Valbypark, Copenhagen was constructed by
Jørgen Thordrup in April 1995. It is in the children's play
area, just behind the cafe. It is around 40 feet (12 metres)
in diameter, an 11-circuit, classical Scandinavian design.

'Trojaborg', Visby, Gotland, Sweden

This labyrinth, on the island of Gotland at Visby, is
probably the best known stone pathway in Scandinavia.
The island of Gotland also has a number of other very old
stone labyrinths and church frescoes. This one is just north
of the town, beyond the hospital. It is on public open
ground, below the Galgberget. Its entrance faces the sea. It
is constructed of stones with turf growing on top. Like
many Troy towns, it seems to have received its name from
a medieval habit of naming labyrinths after ancient cities.

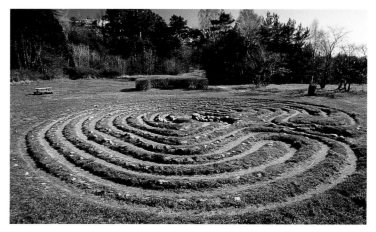

'Trällebergs Slott', Ulmekärr, Sweden

The name of this labyrinth simply means 'round castle.'
It lies in northern Bohuslän just north of Grebbestad,
alongside the road to Havstenssund. About 42 feet
(12.8 metres) in diameter, it is beautifully preserved and
is in an area famous for rock art and other prehistoric
monuments. Like many other Scandinavian labyrinths, it
is located close to the sea and was probably walked by
fishermen for good luck before they headed out.

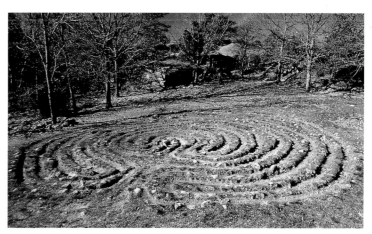

Resources: USA

The Labyrinth Society
Global society and website, labyrinth forum, annual conference.
PO Box 144, New Canaan,
CT 06840-0144
Tel: +1 (877) 446-4520 (Toll free within the U.S.A.)
email: labsociety@aol.com
website: www.labyrinthsociety.org

Earthwork Labyrinths, California
Alex Champion, maker of labyrinths and other geometric symbols.
PO Box 145, Philo, CA 95466
Tel: +1 (707) 895-3375
email: ac@earthsymbols.com
website: www.earthsymbols.com

Relax-4-Life: Neal Harris, Illinois
Affordable wood finger labyrinths.
Tel: +1 (847) 842-1752
Fax: +1 (847) 842-1751
email: relax-4life@aol.com
website: www.labyrinthproducts.com

Lynn Goodman M.F.T. & Spiritual Director, California
Labyrinth workshops, walks, retreats, in-service training.
550 High St #211, Auburn, CA 95603
Tel: +1 (530) 887-1900 or
(530) 273-6766
email: gracewks @jps.net

Makaha Labyrinth, Hawaii: Healing Heart Foundation
Dr. Neal Pinckney, Director 84-683
Upena St, Makaha, Hawaii 96792
Tel: +1 (808) 696-2428
email: heart@aloha.net
website: www.kumu.org

The St. Louis Labyrinth Project
Robert Ferré–full-time labyrinth maker and lecturer. Canvas and outdoor labyrinths, classes and tours.
128 Slocum Ave, St Louis, MO 63119
Tel: +1 (314) 968-5557
email: robert@labyrinthproject.com
website: www.labyrinthproject.com

The Labyrinth Company, Baltimore
David Tolzmann makes both portable and permanent outdoor labyrinths.
4202 Roland Ave #208, Baltimore,
MD 21210-2768
Tel: +1 (917) 445-4266
email: prism@us.net
website: www.labyrinthcompany.com

The Labyrinth Project of Connecticut Inc: Helen Curry, President
PO Box 813, New Canaan, CT 06840
Tel: +1 (203) 966-5121
email: director@CTlabyrinth.org
website: www.CTlabyrinth.org

Sacred Land Photography
Cindy A. Pavlinac, M.A.
Studio #1, Art Works Downtown
1337 4th St, San Rafael, CA 94901
Tel: +1 (415) 479-1950
email:
CindyP@sacred-land-photography.com
website:
www.sacred-land-photography.com

The Labyrinth Project of Alabama
Annette Reynolds, Director
204 Oak Rd, Birmingham,
AL 35216-1410
Tel: +1 (205) 979-1744
email: AnetRey@aol.com
website: www.danwinter.com/sacredlab/

Labyrinth of the Lake— Canyon Lake, Texas
Rebecca Rodriguez offers workshops and women's circles.
2158 Triple Peak Dr, Canyon Lake,
TX 78133
Tel: +1 (830) 964-5078
email: goddess@compuvision.net
website: www.surrendertotheheart.com

The Ancient Art of Stone Sculpting by Marty Kermeen
Labyrinths designed and created in brick or stone mosaic.
800 Big Rock Ave Plano, IL 60545
Tel: +1 (630) 552-3408
email: artpaver@aol.com
website: www.artpaver.com

Stone Circle, San Francisco
Victoria Stone, MPH—life enhancing environments and labyrinth consulting.
893 Noe St, San Francisco, CA 94114
Tel: +1 (415) 826-0904
email: victoria@stonecircledesign.com
website: www.stonecircledesign.com

Mandala Labyrinth Center— Sacramento, CA
Sue Anne Foster Ph.D, Director. Seminars and consulting service for labyrinths.
5204 Winding Way, Carmichael,
CA 95608
Tel: +1 (916) 486-3745
email: mandala33@aol.com

USA (continued)

Dance of the Labyrinth—Washington D.C.
Sandra Wasko-Flood, artist
Labyrinth installation under glass.
Workshops and events.
57 N St, NW Washington D.C.
Tel: +1 (703) 360-5233
email: ekimdoolf@erols.com

The Goddess Gallery
3288 SE Hawthorne Blvd
Portland OR 97214
Tel: +1 (888) 233-6469
email: goddessg@SpiritOne.com
website: www.Goddess-Gallery.com

Sacred Source/JBL
Sacred Source/JBL carries more than 350 ancient deities.
PO Box 163, Crozet VA 22932
Tel: 1 (800) 290-6203
email: spirit@sacredsource.com
website: www.sacredsource.com

RESOURCES: CANADA/BRITAIN/EUROPE/AUSTRALIA

The Sacred Rainbow Path, Canada
Karen Brousseau runs workshops.
3085 Bouvier Rd, Hammond,
Ontario, Canada
Tel: +1 (613) 487-3604
email: brousseaukd@cyberus.ca
http://root.moose.ca/~labyrinths

Ruth Richardson—Nepean, Canada
Palliative Care Nurse Educator and labyrinth facilitator.
34 Longwood Ave, Nepean,
Ontario, Canada K2H 6G
Tel: +1 (613) 828-2155
email: bcuc@storm.ca

Labyrinthos' Labyrinth Resource Centre and 'Caerdroia', the Journal of Mazes & Labyrinths, U.K.
Jeff Saward, Director
53 Thundersley Grove, Thundersley,
Essex SS7 3EB, U.K.
email: jeff@labyrinthos.net
website: www.labyrinthos.net

Helen Raphael Sands, London, U.K.
Labyrinth facilitator, teacher and author.
email: helenraphael@hotmail.com

Adrian Fisher Maze Design, U.K.
Maze and labyrinth designs worldwide.
Victoria Lodge, 5 Victoria Grove,
Portsmouth, Hampshire, PO5 1NE, U.K.
Tel: +44 (23) 92-355-500
email: adrian@mazemaker.com
website: www.mazemaker.com

Jim Buchanan, Landscape Art, U.K.
Large-scale outdoor environmental art.
3 Greenhead Cottages, Caerlaverock
Castle, Dumfries, Scotland DG1 4RU
Tel: +44 (01) 387-770-400
email: jim.buchanan@virgin.net

Gernot Candolini, Austria
Labyrinth design and workshops.
Innstrasse 35, A-6020 Innsbruck, Austria
Tel. +43 (664) 181-8809
email: candolini@eunet.at
website: www.labyrinthe.at

Labyrinth Project International
Switzerland-based organization of labyrinth designers.
Oeffentliche Frauenplätze, Pf., CH-8135
Langnau am Albis
Tel: Ursula Knecht, +41 (01) 830-69-79
email: kramer.s.w@access.ch
website: www.labyrinth-project.ch/index.html

Begehbare —Labyrinths in Germany
Website of currently walkable German labyrinths with pictures.
Silke Wolf and Werner Kaufmann
Tel: +49 (615) 78-32-94
email: silke.werner@bigfoot.de
website: www.begehbare-labyrinthe.de

Crystal Castle, Australia
Crystal emporium and bookstore.
PO Box 495 Mullumbimby,
NSW, Australia
email: castle@spot.com.au
website: www.crystalcastle.net

FURTHER READING

Artress, Lauren, *Walking a Sacred Path: Rediscovering the Labyrinth as a Sacred Tool*, Riverhead Books, 1995.

Attali, Jacques, *The Labyrinth in Culture and Society: Pathways to Wisdom*, North Atlantic Books, 1999.

Baring, Anne & Cashford, Jules, *The Myth of the Goddess: Evolution of an Image,* Penguin Arkana, 1993.

Burckhardt, Titus, *Alchemy: Science of the Cosmos, Science of the Soul,* transl. William Stoddardt, Penguin, 1967.

Burckhardt, Titus, *Chartres and the Birth of the Cathedral*, transl. William Stoddart, Golgonooza Press, 1995.

Campbell, Joseph, *The Masks of God: Primitive Mythology*, Penguin Books, 1976.

Champion, Alex B, *Earth Mazes*, self-published, 1990. (See Resources for contact details.)

Curry, Helen, *The Way of the Labyrinth: A Powerful Meditation for Everyday Life*, Penguin Compass, 2000.

Doob, Penelope Reed, *The Idea of the Labyrinth from Classical Antiquity through the Middle Ages*, Cornell University Press, 1990.

Fisher, Adrian and Gerster, Georg, *The Art of the Maze*, Weidenfeld and Nicolson, 1990.

Graves, Robert, *The Greek Myths,* Vols I and II, Penguin Books, New York, 1957.

Haskins, Charles Homer, *The Renaissance of the 12th Century*, Meridian Books, 1967.

Jaskolski, Helmut, *The Labyrinth: Symbol of Fear, Rebirth, and Liberation*, transl. Michael Kohn. Shambala, 1997.

Kern, Hermann, *Through the Labyrinth: Designs and Meanings over 5,000 Years*, Prestel, 2000.

Lonegren, Sig, *Labyrinths: Ancient Myths and Modern Uses*, Gothic Image Publications, 1991/1996.

Matthews, W. H, *Mazes and Labyrinths: Their History and Development*, Dover, 1985.

Pennick, Nigel, *Mazes and Labyrinths*, Robert Hale, 1990.

Sands, Helen Raphael, *The Labyrinth: Pathway to Meditation and Healing*, Gaia Books/Barrons (US), 2001.

West, Melissa Gayle, *Exploring the Labyrinth: A Guide for Healing and Spiritual Growth*, Broadway Books, 2000.

PICTURE CREDITS

b = bottom, t = top, c = center, l = left, r = right, i = illustration

Peter Bauer: 106(*bl*); Bells Corner United Church: 101(*cr*); Bridgeman Art Library: 24(*b*) Musee du Petit Palais, Avignon, France, Peter Willi, 27(*b*) Museo Nazionale di San Martino, Naples, Italy, 28(*b*) ©Pablo Picasso, 1958/Succession Pablo Picasso. Licensed by VISCOPY, Sydney, 52(*t*) private collection, 55(*tr*) Biblioteca Medicea-Laurenziana, Florence, Italy, 56(*t*) private collection, 56(*b*) British Library, London, 57(*t*) British Library, London, 57(*b*) Bibliotheque Nationale, Paris; 58(*t*) private collection, 59(*b*) Museo del Prado, Madrid, 64(*t*) Solomon R. Guggenheim Museum, New York (we have been unable to trace the copyright holder and would be grateful to receive any information as to their identity), 64(*b*) Victoria & Albert Museum, London; Karen Brousseau: 101(*br*); Jim Buchanan: 76(*bl, br*), 91(*b*), 95(*bl*); Marty Cain: 66(*r*) Gernot Candolini: 61(*t*), 77(*tr, 2nd from tl, br*), 71(*cl & tr*), 83(*t*), 106(*tr, br*); Alex Champion: 75(*tr & cr*), 71(*2nd from bl, bc, br*); Helen Curry: 81(*t*); Roland Dorsey: 94(*t*) courtesy the *Dundalk Eagle*; Michael Engler: 91(*t*) courtesy Bilderberg, Hamburg; Toby Evans: 71(*tc*), 100(*3rd from tl & bl*); Robert Ferré: 71(*bc*), 73(*br*), 87(*br*), 99(*t*); Adrian Fisher Maze Design: 2, 11, 76(*tl, 2nd from tl, cr*), 103(*tr & br*); Fortean Picture Library: 23(*t*), 25(*bl*), 29(*c*), 60(*r, bl*); Sue Anne Foster: 5(*c*), 82(*t*); courtesy Goddess Gallery: 43(*l*) Isis relief, original from the Temple of Isis, Philae, Egypt, 345BC; Heraklion Museum, courtesy Greek National Tourism Office: 24(t), 26; Martin Gregory: back flap of jacket(*b*); Hever Castle Ltd: 60(*t*); Marty Kermeen: 62, 74(*tl, tr & cr*), 80(*t*); Bernd Krug: 67(*r*), 95(*t & c*); courtesy Labyrinth Project International: 77(*cl*), 89(*b*), 105(*c*) © Maurice K. Grünig; Erich Lessing/Art Resource, NY: 38; John McCormick: 69(*t*) courtesy the Crystal Castle; Arthur Meehan: 76(*3rd from tl*); Reg Morrison: 34(*t*); courtesy Malta Tourist Office: 36(*t*); Heinz Naab: 106(*cl*); Neal Pinckney: 70(*b*); Alan Orling: 70(*t*), 75(*bl*); Cindy Pavlinac: Cover(*front and back*), 5(*b*), 8–10, 13, 13(*i*) (this image repeated throughout), 14, 19(*b*), 22, 27(*t*), 31(*b*), 35(*t, cr*), 36(*b*), 41(*b*), 49(*tl*), 50(*l*), 52(*bl*), 55(*bl*), 58(*b*), 63, 66(*l*), 67(*l*), 69(*b*), 71(*3rd from tc, 2nd from tr*), 75(*tl*), 78, 81(*b*), 83(*b*), 84(*b*), 87(*l*), 88, 89(*t*), 90, 92, 93, 98, 99(*bl*), 100(*t, 2nd from tl & tr*), 102 (*tr*), 104(*tl, cl, bl, tr & br*); Pamela Ramadei: 71(*2nd from tc*); Paula Rendino: 71(*bl*); Rebecca Rodriguez: 80(*b*); Helen Raphael Sands: 17(*t*); Jeff Saward: 4, 5(*t*), 6, 21, 25(*br*), 28(*t*), 29(*t & b*), 30, 31(*c*), 32(*tr, cl & bl*), 33(*c & b*), 34(*br*), 35(*bl, *)37(*b*), 39(*t*), 40(*l*), 44, 45(*b*), 47, 48(*cl & bl*), 49(*br*), 54(*l*), 59(*t*), 65, 68, 71(*tl*), 87(*t*), 89(*i*), 102(*tl, cl & bl*), 103 (*all on left-hand side*), 106(*tl*), 107; Rosemarie Schmid: 18; Anthony Scibilia/Art Resource, NY: 49(*bl*); Stephne Sheatsley: 41(*t*); Robert Smith: 82(*b*), courtesy Johns Hopkins Medical Centre, 100(*br*); Sonia Halliday Photographs: 46; Victoria Stone: 74(*c, bl & br*); Peggy Thompson: 86; David Tolzmann: 75(*cr & br*); Sacred Source: 42(*br*); Sandra Wasko-Flood: 94(*b*); David J Weinlader: 72, 99(*br*); Virginia Westbury: 1, 7(*i*), 12, 15, 17(*b*), 19(*t*), 20, 23(*b*), 24(*i*), 25(*t*), 26(*ic*), 27(*c*), 31(*i*), 32(*tl & br*), 33(*t*), 34(*bl*), 37(*t*), 39(*b*), 40(*br*), 42(*t & bl*), 43(*r*), 45(*t*), 48(*t*), 49(*tr*), 50(*r*), 51, 52(*br*) courtesy Badische Landesbibliothek, 53(*br*) courtesy Osterreichische Nationalbibliothek, 53(*first 3 ill l-r*) 54(*c & r*), 55(*br*), 61(*b*), 73(*l*), 79(*b*), 84(*t*), 85, 104(*cr*).

INDEX

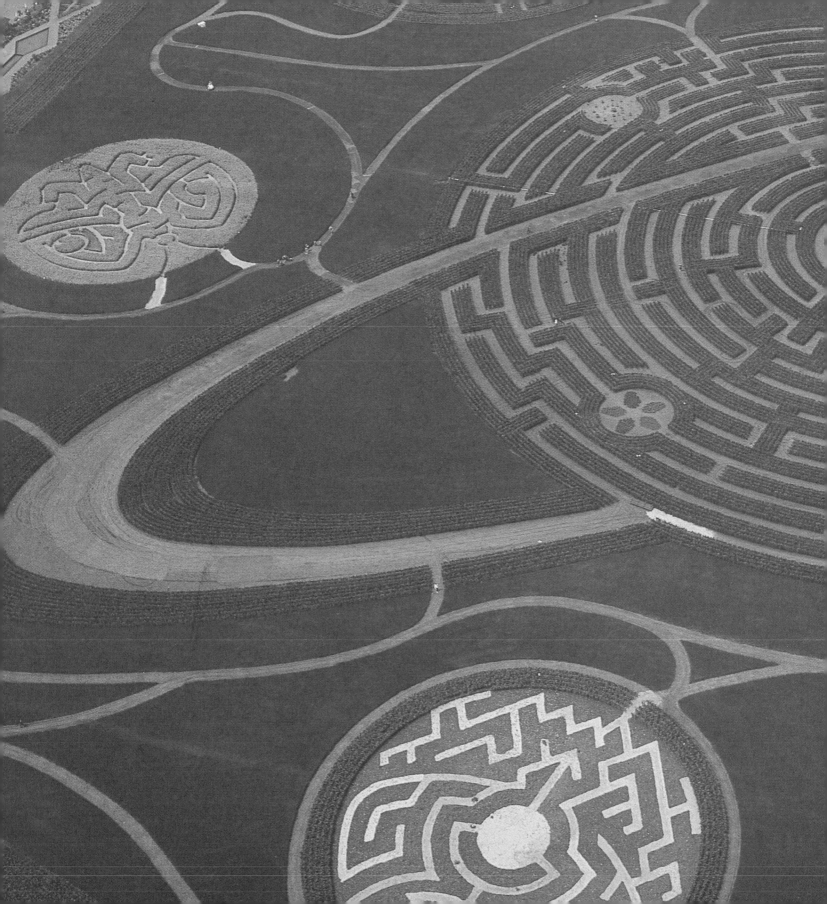